D0922614

IMAGES
of America

NEW ALBANY

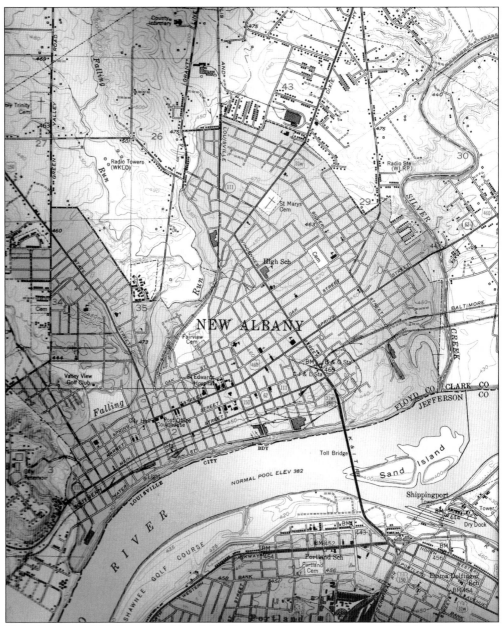

NEW ALBANY, 1950. Interstate 64 and the Sherman Minton Bridge were still a decade away, and the Kentucky and Indiana Railroad Bridge was the only span across the Ohio River from New Albany to Kentucky when the United States Department of the Interior made this topographical map of the area in 1950. Though plans for a flood wall were finalized, construction had not begun in Floyd County, and Water Street still ran along New Albany's riverfront.

On the cover: New Albany Steam Laundry Dry Cleaning was located in the Gibson Building on Pearl Street, south of Main Street. The original building was built in 1825. Pictured with the company's fleet of delivery trucks in the 1950s are Gene Neidieffer and Leonard Vinners (in hat). (Courtesy Sharon Gullett.)

IMAGES
of America

NEW ALBANY

Enjoy!

Gregg Seidl

7/20/06

Gregg Seidl

ARCADIA
PUBLISHING

Copyright © 2006 by Gregg Seidl
ISBN 0-7385-4063-3

Published by Arcadia Publishing
Charleston SC, Chicago IL, Portsmouth NH, San Francisco CA

Printed in the United States of America

Library of Congress Catalog Card Number: 2006922111

For all general information contact Arcadia Publishing at:
Telephone 843-853-2070
Fax 843-853-0044
E-mail sales@arcadiapublishing.com
For customer service and orders:
Toll-Free 1-888-313-2665

Visit us on the Internet at http://www.arcadiapublishing.com

*I acquired my love of reading and history in the private library of my
great aunts, Virginia Fothergill and Ruth and Margaret Adams.
My nephew Josh Grider, who squeezed more out of life in seven years
than most people do in 70, taught me that sometimes,
"a man's gotta do what a man's gotta do."
This book is dedicated to these four people without whom
it would not have happened.*

CONTENTS

ACKNOWLEDGMENTS

This is a book about New Albany, Indiana, and the people who have called the city home. Some stayed only a night, but many of the surnames of the town's first settlers are found in contemporary city directories. Their experiences along the banks of the mighty Ohio River left imprints, however faint, on the sidewalks and streets of the town, and this book tells but a few of their stories.

Several New Albanians shared their time and treasured family photographs with me. I want to thank Janis Bilbro, Kim Campbell, Pastor Billy Craddock, Nancy Ford, Rachel Hogan, Mickey Kahl, Sandy Kirk, Terry Middleton, Ramon at Los Indios, Charles Spencer, Joseph Stein, Bill Volkmer, Antoinette Waughtel, and Joe and Wilma Zink. I want to extend a special thank-you to Sharon Gullett, who allowed me to mangle her treasured family scrapbooks, and to Floyd County historian, author, and educator David Barksdale, who took time from his busy schedule on numerous occasions to share with me his photographs and vast knowledge of New Albany's history. Thanks to the staff of the Indiana Room in the New Albany-Floyd County Library, Lynn Rueff, Greg Rothenberger, Betty Menges, Patricia Foster, Beth Nolan, and Nancy Strickland, for their hard work and generous contributions to this book.

Nancy Falkenstein, Tresa Reynolds, Jerry Rogers, Shirley Schultz, and Dr. William Sweigart are but a few of the teachers who shaped my writing skills and made this book possible. Walt Jackson and Patricia Spencer in the Writing Center at Indiana University Southeast have also provided me with direction over the years, and if not for the patient guidance of my mentor, Dr. John Findling, I would be dodging spitballs in an eighth-grade grammar class instead of writing this. John I owe you a debt I intend to repay one beer at a time.

I especially wish to thank my editor at Arcadia, Anna Wilson, for giving me this wonderful opportunity. Thanks to the entire staff at Arcadia for making this a pleasant and rewarding experience.

Finally I want to extend my deepest appreciation to my underpaid, overworked, most appreciated, and much loved fiancé/assistant/confidant, Corine Miller, for her patience, understanding, and support. Thanks to you, Corine, I believe I can fly.

My sincerest apologies are extended to anyone I have inadvertently omitted.

INTRODUCTION

In 1812, three brothers from New York—Abner, Joel, and Nathaniel Scribner—paid Col. John Paul $10 an acre for approximately 880 acres of land that rose in a gentle slope from the western end of the falls of the Ohio River to the hardwood covered hills surrounding them. The sum of $10 an acre was five times the going rate for undeveloped frontier land, but the Scribner's thought the price fair for the land they envisioned as the future head of downriver navigation. They named their new town New Albany in honor of the capital of their home state, and the small settlement rapidly grew into a major river city. But the Scribner's were not the first people to call New Albany home.

Several cabins were scattered throughout the dense forest when the brothers bought the land from Colonel Paul, and local legend claims John Carson was the first white man to settle in the area. Carson allegedly squatted at the mouth of Silver Creek and ferried Native Americans and others across the creek when high water made the passage at the Gut Ford impossible. Robert LaFollette was probably the first white to formally declare the area his home, but for thousands of years before he built his cabin near the Knobs, clans of Native Americans established temporary camps that extended for miles along the northern riverbanks as they paused on their annual migrations from winter hunting grounds to summer ones; their artifacts are easily found in freshly tilled soil of the flood plain.

When New Albany was first incorporated in 1817, the city was in Clark County. But after John Eastburn, Seth Woodruff, Joel and James Scribner, and the firm of Smith and Paxton pledged $9,000 and four public lots for the town's use, Floyd County was carved out of the territory of Clark and Harrison Counties on March 4, 1819, and New Albany was named the county seat. Despite some initial financial difficulties, the town profited from its location on the downriver end of the falls, and by 1850, was Indiana's largest city, the home of several diverse industries that ranged from steamboat construction to plate glass manufacturing.

The first plate glass window installed in a store in the United States was installed in John Heib's tailor shop on Pearl Street and came from John Ford's American Plate Glass. Ford's factory, built between William Culbertson's mansion on Main Street and the river, was the first plate glass manufacturing plant in North America. Culbertson may have been upset that the factory blocked his view of the river; he invested in every glass manufacturer in New Albany but Ford's.

The manufacture of steel and leather goods helped the city overcome a temporary depression in the 1890s, and despite an enormous fire that almost wiped out the entire western portion of the city, New Albany was prospering at the close of the 19th century. The city was the world's

leader in the plywood and veneer industry, and its textiles and sheet music were nationally renowned. As the town prospered and grew, many churches found the need for larger facilities to accommodate their growing congregations and several took advantage of the economic heyday to construct new buildings. New Albany, which has often been referred to as the "City of Churches," has always had a diverse religious community, and the large number of churches in the town attests to the religious toleration of the city's residents.

The good times continued through the early years of the 1900s, but in March 1917, amidst the hardships created by World War I, a tornado devastated the northern end of the town. Temporarily forgetting the difficulties imposed on them by the man-made conflict, New Albanians rallied to the aid of their friends and neighbors harmed by the natural disaster, and the town quickly recovered.

New Albany's location on the river has always been both a blessing and a curse. Massive flooding was reported in 1832 when the river crested at 69 feet, and in February 1864, the floodwaters rose to an unprecedented 74 feet. In January 1937, in the middle of the Great Depression, more than 5,000 people applied for aid when the river crested at over 85 feet. Damages to the city were estimated at $8 million. In the early 1950s, construction began on a flood wall in an effort to protect the city from the river's yearly floods.

The city's tax base increased with the construction of several factories in the early 1950s, and in 1956, Mayor C. Pralle Erni and his city council used the authority and clout this economic windfall provided them to annex a portion of Floyd County that effectively doubled the town's population and physical size. The *Saturday Evening Post* reported: "In the fierce competition among cities to attract new industry, the historic river town had suddenly become a formidable contender." The town continues to experience new growth and remains a contender today.

One

AROUND TOWN

New Albany has changed. Some 350 million years before the Scribner's felled the first tree, New Albany was covered by a huge inland sea inhabited by strange creatures and exotic plants. The ocean receded, and glaciers sculpted the flat seabed into the deep ravines and steep hillsides that surround the city today. Tornados and floodwaters also reshaped the terrain. But, of all the forces that have altered the landscape, none has had a more permanent impact than man.

When the Scribner's laid out the town, the city stretched from the river north to where Oak Street is today, and from East Fifth to West Fifth Streets. State Street was the centerline of the town. Water Street (River Road) was 100 feet wide, and High (Main), Market, and Spring Streets were 80 feet across. The deep and spacious lots lining the broad streets were first offered at public auction on November 2 and 3, 1813. William B. Summers, the first winning bidder, paid $234 for a 60 by 120 foot lot stretching from High Street to Upper First (Pearl) Street.

Five years later, Gershom Flagg, emigrating from New England to Illinois, recorded his impression of the New Albany area in a letter to his brother: "Got tossed about some at the fall of the Ohio opposite Louisville . . . the large boats & Steam Boats cannot pass except in the Spring or fall [sic]. It is a very dismal looking place." Flagg would not recognize the beautiful city the "dismal looking place" has become.

Over the years, New Albany annexed huge tracts of surrounding Floyd County land. The largest, in 1956, doubled the physical size of the city, added almost 7,000 new residents, and immediately enlarged the city coffers by $9 million. The New Albany/Floyd County area continues to grow in size, stature, and prosperity, and although the landscape has changed, many today will recognize several of the scenes of yesteryear contained in this chapter.

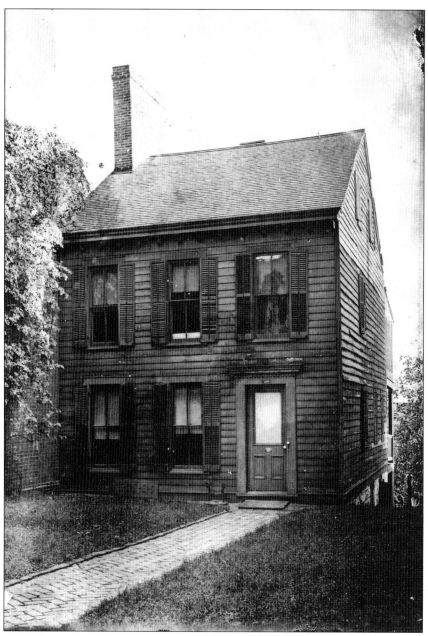

NEW ALBANY'S OLDEST HOME. Joel Scribner built this clapboard house, the first frame dwelling in the city, in 1814. Compared to its log cabin neighbors, the home, pictured here around 1904, was spacious and elegant. The rooms on the first floor were primarily used for socializing and dining. The second floor held two bedrooms and a nursery, and the Scribner children used the third floor as a play area. The kitchen was in the basement of the home. Double porches on the rear of the house provided spectacular views of the mighty Ohio River and the bustling waterfront of the fast growing settlement. The Piankeshaw Chapter of the Daughters of the American Revolution bought the property from Harriet Scribner in 1917, and allowed her to live in the home until her death in 1932. Today the shining white house and its beautiful gardens provide a peaceful oasis on the busy corner of State and Main Streets. (Courtesy Indiana Room.)

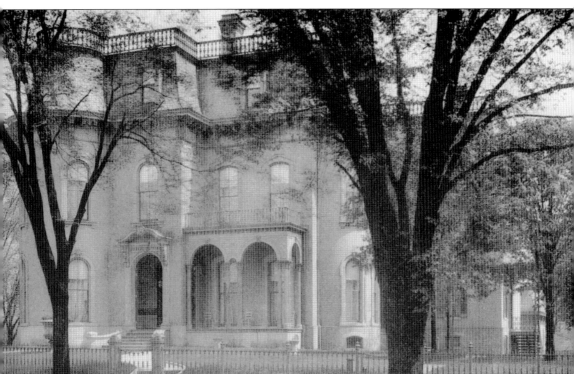

THE CULBERTSON MANSION. William Culbertson bought an entire city block on the eastern edge of town in the early 1860s to build this spectacular French Second Empire–style home for his second wife, Cornelia, but a shortage of skilled laborers delayed construction until the "Southern Rebellion" was suppressed, and Cornelia never lived in the magnificent home on Main Street. She died of typhoid pneumonia before the 20,000 square foot mansion was completed in 1867. Culbertson eventually remarried, and the newlyweds filled the 25-room home with art, furniture, and curiosities they found on their six-month honeymoon adventure through Europe, Asia, and Africa. His youngest daughter, Blanche, accompanied them on their trip. Not long after his death in 1893, Culbertson's widow built a new home across the river in Louisville, Kentucky, because Louisville had one very important amenity most of New Albany lacked at the time—electricity. The mansion was leased out while Culbertson's heirs battled in court, and when John McDonald eventually bought the home at auction, he paid only $7,000; construction had cost approximately $120,000. (Courtesy Indiana Room.)

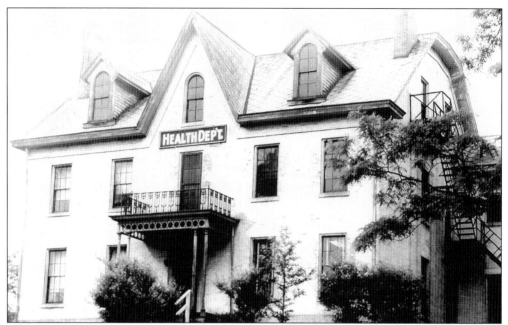

CORNELIA CULBERTSON MEMORIAL ORPHANAGE. To honor Cornelia, William Culbertson had this orphanage built on Ekin Street in 1882 for a reported $22,000. The children who lived here were given one issue of clean underclothing a week, after their weekly bath on Saturday. When the orphanage closed, the Floyd County Health Department used the building, which was eventually razed to make room for an apartment complex. (Courtesy the Cody Collection.)

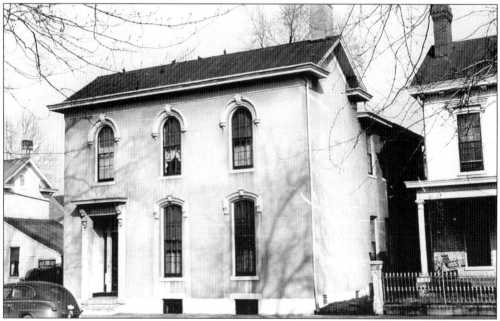

AT 224 WASHINGTON PLACE. James Kepley, a plasterer, and his wife Virginia shared their home with his brothers Ferdinand, a carpenter, and Artie, a seamster for the Works Progress Administration, when this photograph was taken in the 1940s. The home was removed when Interstate 64 was built in the late 1950s. (Courtesy the Cody Collection.)

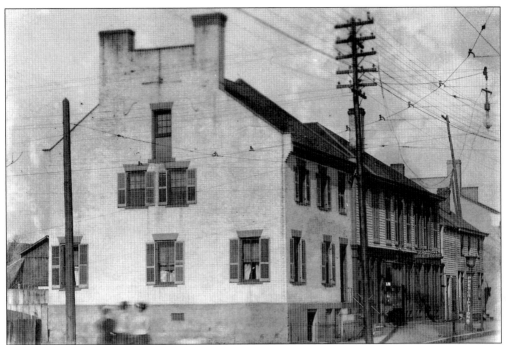

NORTHEAST CORNER OF EAST FOURTH AND MAIN STREETS. Dr. Stephen J. Alexander operated Alexander's Drug Store with his wife Mary next door to this boarding house from 1882 until his retirement in May 1932. Though this structure was razed, others were converted to multi-family dwellings, and most are being restored to single-family units as New Albanians rediscover the grace and elegance of living in a Main Street mansion. (Courtesy the Cody Collection.)

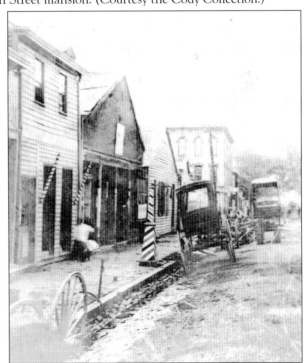

PEARL STREET, NORTH TOWARD SPRING STREET. These homes and businesses on the west side of Pearl Street were torn down to make room for a new post office and federal building soon after this photograph was taken in the early 1900s. (Courtesy Indiana Room.)

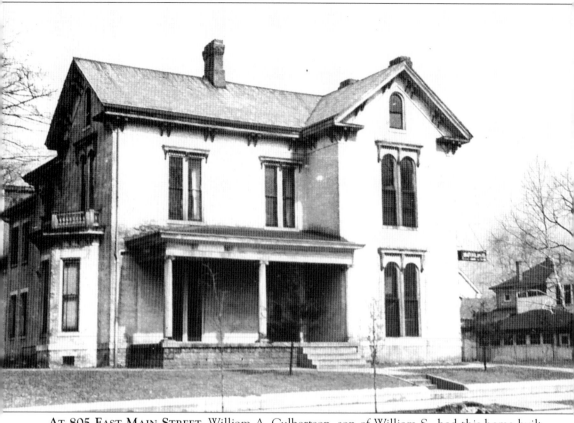

At 805 East Main Street. William A. Culbertson, son of William S., had this home built on Main Street in 1866. John F. Gebhart, owner of the New Albany Woolen and Cotton Mills, moved into the home with his wife Rosa and their two sons, Ridgeway and John R. The mills, located on Vincennes Street, employed 800 workers and were the largest textile concern in the Midwest. Gebhart, owner of several patents, was a major proponent for telephone and waterworks in the city and was one of the powerful New Albany tycoons behind the Kentucky and Indiana Railroad Bridge. He died in March 1907. Rosa passed away in January 1933, at the age of 89, at Ridgeway's home in Nashville, Tennessee. The Catholic Young Men's Institute acquired the property, and the building served as the Catholic Community Center until the New Albany chapter of the Knight's of Columbus decided to use the former home as their headquarters. This photograph was taken in 1929. (Courtesy the Cody Collection.)

Looking West on Pearl Street, Between Main and Market Streets. The migration from the inner city to the suburbs hurt businesses in the downtown districts of many small towns across America. When New Albany's city council voted against the construction of a shopping mall along the State Street corridor in the 1960s, authorities in nearby Clarksville successfully petitioned for the mall. Though some downtown businesses survived the suburban exodus, others were forced to either close or move. This photograph was taken in May 1981.

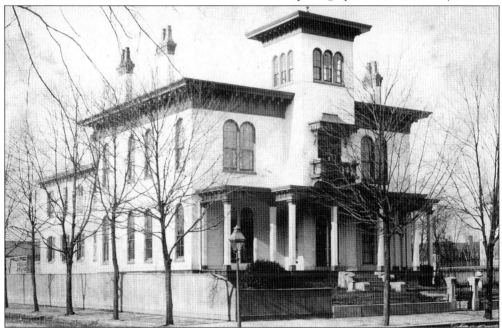

At 1003 East Main Street. Victor A. Pepin had this Italianate-style home built in 1851. In 1863, John P. Cromie bought the home for $7,500. Cromie came to New Albany in 1850 and went into the grocery business with John T. Creed. Cromie, the first to sell "lake ice" in New Albany, died of "erysipelas" on December 12, 1884. August Barth, owner of the Barth Tannery, bought the home in 1887 for $10,000. (Courtesy the Cody Collection.)

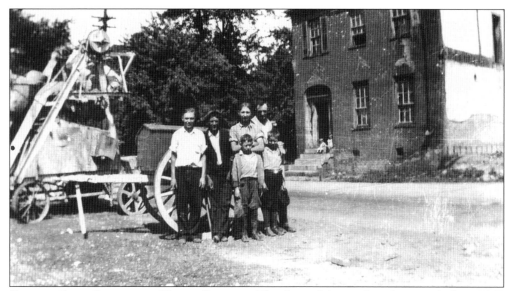

CORNER EAST SIXTH AND WATER STREETS. The four adults in this photograph from 1927 are, from left to right, Albert Ramsey, Everett Best, Charles Gullett, and Ted Bowers. The two children standing with them are Sherman (left) and Kepley Whitten (right). The children sitting on the steps in front of the house are unidentified. (Courtesy Sharon Gullett.)

LATER THAT SAME DAY. When the boys were done, the ladies took their turn posing for the photographer, but modesty and pride made Bertha Ramsey (left) and Nona Bowers (right) turn away from the camera; they did not want the prying lens to record their pregnant stomachs. (Courtesy Sharon Gullett.)

AT 2105 RENO AVENUE. Marvin G. Collins and his wife Katherine raised their children in this modest bungalow on Reno Avenue. Marvin was an agent for the Prudential Life Insurance Company. Karl and Dorothy Walters lived next door at 2107, and the two families were close friends when this picture was taken sometime in the late 1930s or early 1940s.

RENO AVENUE. This view, looking east down Reno Avenue from Silver Street, reflects the vision the Scribner brothers had for wide tree-lined streets in the city. Water Street (River Road) was originally 100 feet wide, and High (Main), Market, and Spring Streets, were 80 feet across. The street appears much the same today as it did when this photograph was taken in 1939.

JANUARY 1940. Snow and ice covered the intersection of Reno Avenue and Silver Street when a cold spell dropped the temperature to five degrees below zero for several days in a row. Parts of the Ohio River froze, trapping and destroying many small pleasure craft docked in the river. Most New Albany homes and businesses were heated by coal, and coal prices remained low during the cold weather.

SILVER HILLS. Jacob Walters and his wife Rose owned and operated a small grocery store on the Corydon Pike when, in the winter of 1940, an unknown photographer took this picture of the Silver Hills from the store's porch. The Walters' son, Karl, a department manager for Sears, lived with his wife Dorothy at 2107 Reno Avenue.

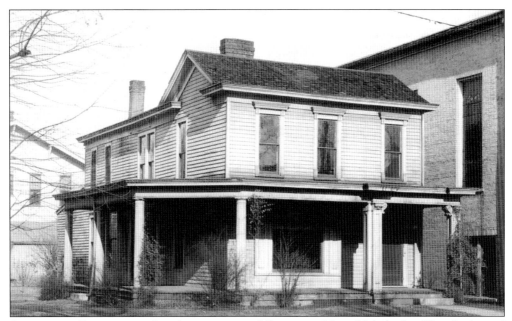

CENTENARY PARSONAGE. One former pastor of Centenary United Methodist Church claimed the parsonage, located next to the church, was so old, it reached from "Dan to Beersheba." Rev. George Dalrymple had this building demolished in late 1934. Dedication services for the new parsonage, built for approximately $8,500, were held on July 7, 1935. Building committee members were Roscoe H. Lewis, Frank D. Morris, Floyd Roach, and Charles Drayer. (Courtesy Centenary United Methodist Church.)

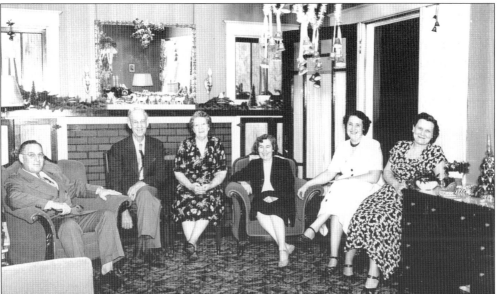

CHRISTMAS, 1951. Visitors of the Reverend Robert G. Skidmore and his wife, Merle, stayed warm and comfortable during the Christmas season thanks to a new oil-fired heater installed in the parsonage the year before. Skidmore served as pastor of Centenary United Methodist Church for four years. Pictured from left to right are Reverend Skidmore, A. J. Blake, ? Blake, Merle Skidmore, Clarana Kron, and Thelma Payne. (Courtesy Centenary United Methodist Church.)

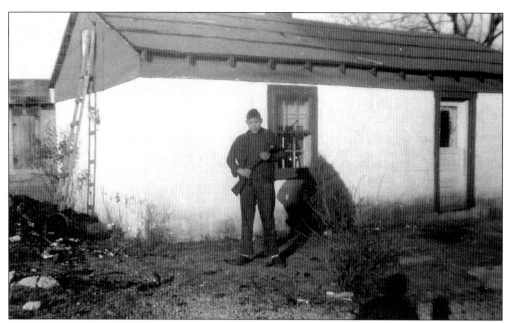

GULLETT FAMILY HOME, 1953. Larry Gullett posed in front of the two-room house his family lived in on Grantline Road with the Remington .22 caliber rifle he bought for his father. The concrete block home, built by his father in 1946, had no running water. Gullett shared the home with his parents, Charles and Geneva Gullett, brother Wayne, and sister Sharon. (Courtesy Sharon Gullett.)

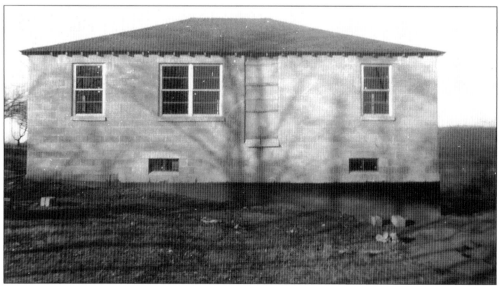

GULLETT FAMILY HOME, 1955. Larry Gullett designed the plans for this concrete block house on Grantline Road, which replaced the family's first home. Members of the family built the house next to the first home. In the early 1970s, Indiana University Southeast was built on land adjacent to the 15 acres the family owned. (Courtesy Sharon Gullett.)

AT 2106 MORTON AVENUE. Charles and Martha Fothergill bought this home after moving to New Albany from Ghent, Kentucky, in the 1950s. The Fothergills lived on Morton Avenue with their two daughters, Janet and Valerie. "Charlie" Fothergill retired from General Electric in 1980 and died in 2000. Martha, who never held a driver's license, was a housewife and died in 2004. (Courtesy Janet Armstrong.)

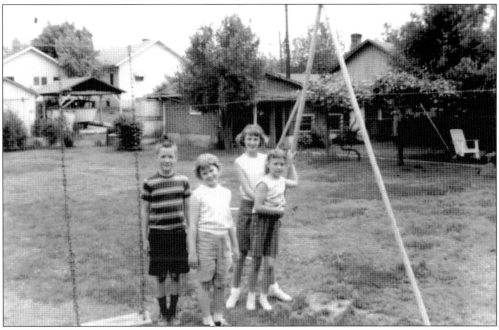

MORTON AVENUE. The homes on Morton Avenue were spacious middle-class homes with huge backyards. Pictured in the Fothergill's backyard from left to right are David Eberle, Susan Williams, Sandy Williams, and Valerie Fothergill. The Eberles lived next door to the Fothergills, and the Williams sisters lived across the street. (Courtesy Valerie Pullen.)

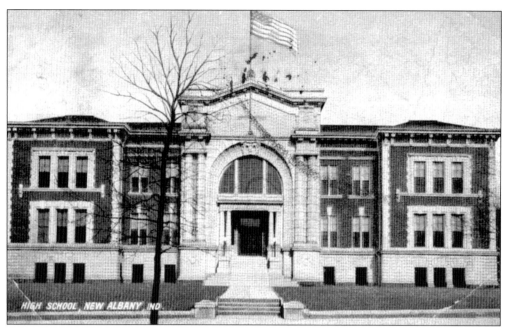

NEW ALBANY HIGH SCHOOL, 1909. H. A. Buerk, father of local football, was principal of the "Peoples College" when it opened on East Spring Street, in the block between East Fifth and Sixth Streets, in 1904. United States Supreme Court justice Sherman Minton graduated from the high school in 1910. The building served as the senior high school until 1928 and was the junior high school until 1960.

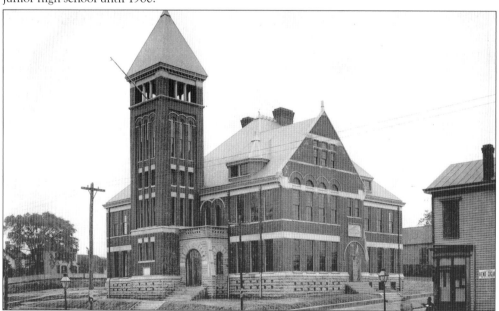

CORA MARTIN SCHOOL, 1892. The current high school, built to the left of this picture, annexed the old school, and several generations of students braved inclement weather as they traversed the alley between the high school and "the Annex." Deemed too costly to maintain, the building was demolished to make room for the high school swimming pool complex in the early 1980s. (Courtesy Indiana Room.)

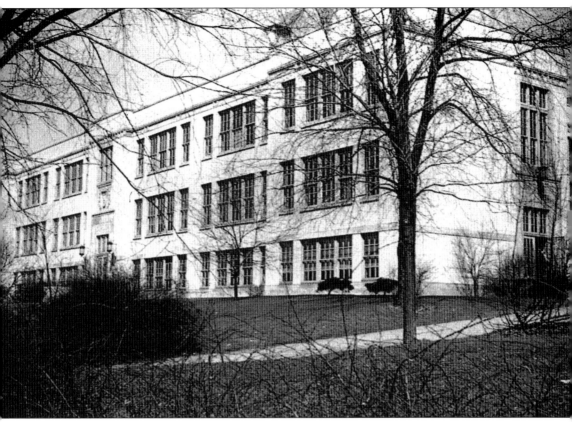

NEW ALBANY HIGH SCHOOL, VINCENNES STREET, 1940. Founded in 1853, the New Albany High School is the oldest public high school in Indiana, although classes have been held at several different locations. Baseball Hall of Famer Billy Herman; winner of the Masters in 1979 and the U.S. Open in 1984, Frank "Fuzzy" Zoeller; 1976 Olympic silver medallist Camille Wright; and world record holder in the high jump, Jeff Woodard are only four of the athletic alumni from the school. Several individuals and teams have won state titles, but athletics are not the only profession the school's alumni have excelled in. The famous astronomer Edwin P. Hubble taught here in the 1920s, and Marion Richardson Byrn, class of 1943, was 12 when she won the National Spelling Bee; poet and playwright William Vaughn Moody graduated in 1885, and internationally renowned jazz saxophonist Jamie Aebersold in 1957. Regina Overton, class of 1960, was the first female mayor of New Albany. Cathi Bennet, class of 1984; Dayna Brewer, class of 1988; and Shani Nelson, class of 1990, held the title of Miss Indiana in 1991, 1993, and 1996 respectively.

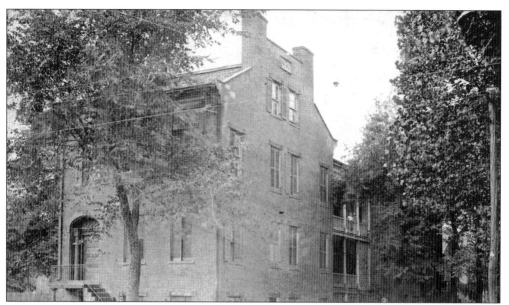

ANDERSON FEMALE SEMINARY. The Anderson Female Seminary was located on the northwest corner of Scribner Park at West Main Street and LaFayette Avenue. Main Street, Market Street, LaFayette Avenue, and Washington Street bordered the park. The seminary and the park were razed when the Sherman Minton Bridge was built in the late 1950s. (Courtesy Indiana Room.)

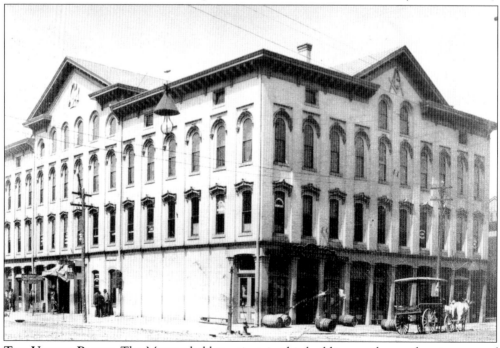

THE VERNIA BLOCK. The Masons held meetings in this building on the northwest corner of Spring and Pearl Streets. Legal and dental services were offered on the upper floors, and liquor, lime, cement, sand, salt, mill, feed, cigars, oats, flour, bacon, and other "country produce" were available in Fred Wunderlich's store on the ground floor. Wunderlich's wooden kegs are scattered across the sidewalk in this photograph from the 1890s. (Courtesy the Cody Collection.)

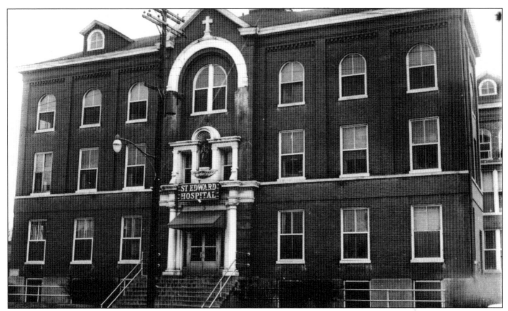

ST. EDWARDS'S HOSPITAL. New Albany's first public hospital opened on the corner of Spring and Seventh Streets in 1902. In 1963, the former hospital reopened as a retirement home. Slated for demolition in the early 1990s, the building was saved when New Directions Housing Corporation converted the former hospital into the St. Edward Court Apartments. (Courtesy Indiana Room.)

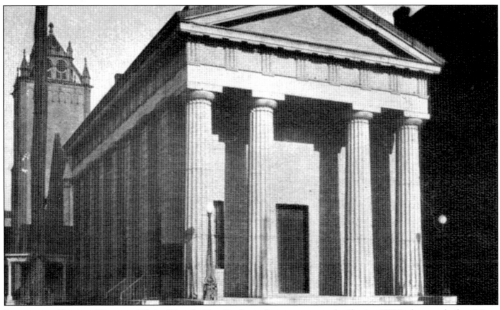

INDIANA STATE BANK. This Greek Revival–style structure, built in 1837, housed the New Albany branch of the Indiana State Bank. The branch served Floyd, Harrison, Washington, Crawford, and Clark Counties in southern Indiana until 1857. Since then, the building has had several owners and functions. Parthenon Special Events and Third Century Interior Designs currently share the building. The First Presbyterian Church is seen in the left rear of this postcard from 1908.

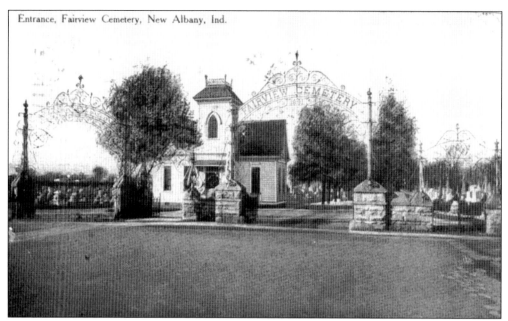

Entrance, Fairview Cemetery, New Albany, Ind.

FAIRVIEW CEMETERY, 1909. The city's second cemetery was created on July 30, 1841, and groundbreaking ceremonies were held when the first burial took place the following day. The iron entrance gate was added in 1890, and in 1896, the cemetery was named Fairview Cemetery. Among those buried here are Indiana governor Ashbel P. Willard, Revolutionary War veteran Richard Lord Jones, and 14 victims from the steamboat *Lucy Walker*, which exploded below the city on October 23, 1844.

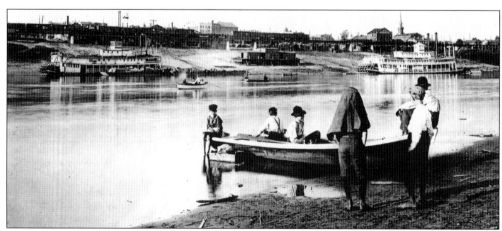

NEW ALBANY'S RIVERFRONT AT THE BEGINNING OF THE 20TH CENTURY. Two steamboats, the *Tell City*, right, and the *R. Dunbar*, left, dock along New Albany's busy riverfront, as a train runs along the elevated tracks on the bank in this photograph taken from the Louisville shore. The steeple of the Second Baptist Church is visible in the background. (Courtesy Indiana Room.)

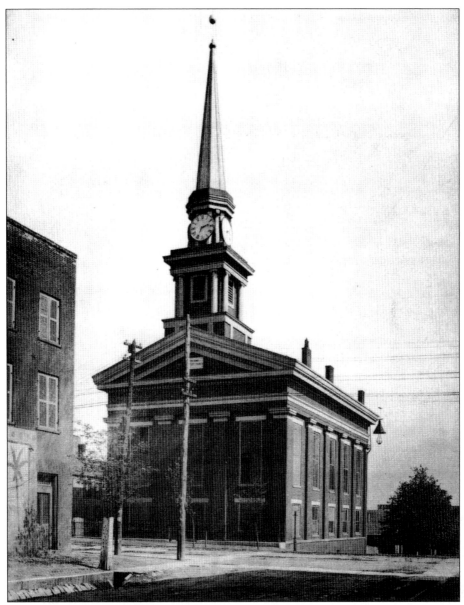

SECOND BAPTIST CHURCH. The clock tower of the Second Baptist Church on Main Street was a beacon that signaled freedom to thousands of escaped slaves making their way north along the various stations of the Underground Railroad. The exact number who sought temporary shelter in the structure can never be known, but hundreds likely passed through the church on their journey. Yet even in the north, sanctuary and freedom were hardly assured. Bounty hunters and kidnappers roamed New Albany's streets, and knocked senseless any unwary blacks they encountered. No matter that the unfortunate victim was the freeborn son of a freeborn father, the dark pigmentation of his skin doomed him. He was rowed, hog-tied and gagged in the cold, wet bottom of a wooden skiff, across the Ohio River to the slave state of Kentucky, and quickly disappeared in the illicit slave trade. Most New Albanians, if not exactly approving of the practice, seldom interfered; a handful engaged in the immoral trade. The church remains an integral part of New Albany's religious community. (Courtesy Indiana Room.)

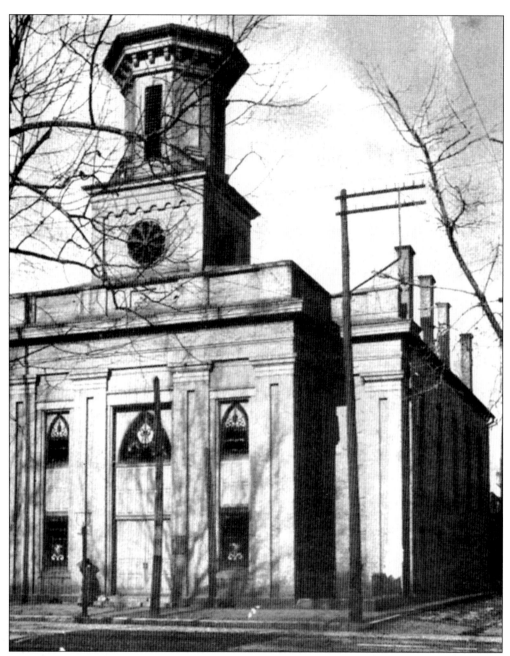

CENTENARY UNITED METHODIST CHURCH, 1909. A series of Methodist revivals in 1838 attracted hundreds of converts to the religion, and Centenary United Methodist Church, named in honor of the 100 year anniversary of the founding of Methodism taking place that year, was built on Spring Street in 1839. The first building measured 50 by 70 feet. A bell was hung in the belfry in 1850 and cracked on a cold Sunday morning during the Civil War. The broken bell was sold, and the money used to pay off some of the church's debts. The scrap metal was melted down and reshaped as cannon balls. A bolt of lightening destroyed the steeple on May 5, 1900. The church remains an integral part of the city's social and religious life, and worship services begin every Sunday at 10:00 a.m. (Courtesy Dr. John Findling.)

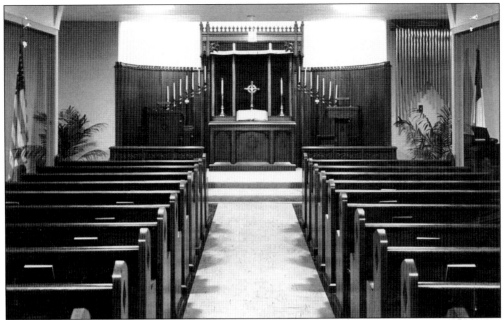

CALVARY CHAPEL IN CENTENARY CHURCH. In 1955, the congregation of Calvary Methodist Church voted to merge with Centenary United Methodist Church and installed the altar and several pews from their old church in the basement of their new one. The combined congregation named this area Calvary Chapel in honor of the old church. The chapel, pictured here in 1960, was moved to another location within Centenary church during renovations in 2000. (Courtesy Centenary United Methodist Church.)

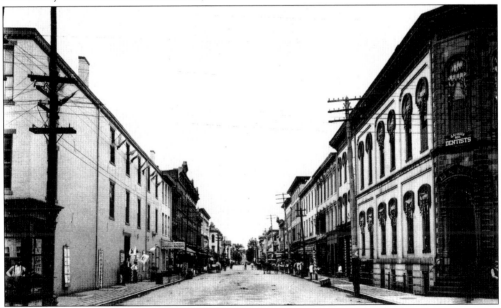

PEARL AND MAIN STREETS, LOOKING NORTH. In 1907, bank officer Jacob Hangary Fawcett was shot and killed during an attempted holdup of the Merchant's National Bank in the building on the right. G. A. Foster and Company Dentists occupied the second floor of the building when this photograph was taken in the late 1890s. (Courtesy Indiana Room.)

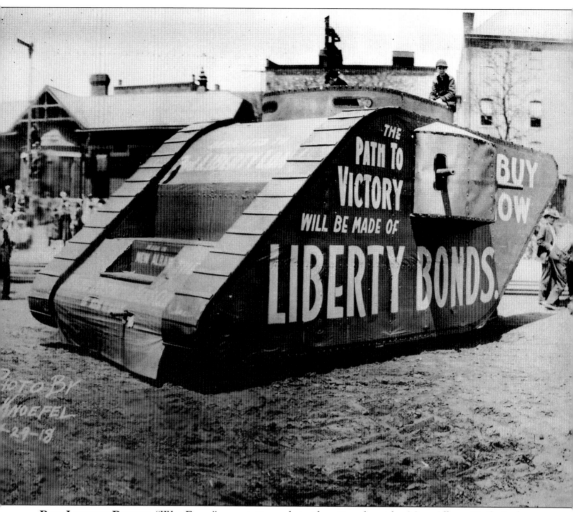

BUY LIBERTY BONDS. "War Fever" was at its peak in the city when the *New Albany Daily Ledger* ran an advertisement on April 20, 1918, that claimed: "When the War Department gets $1,000, it has the funds where with to equip twenty-five soldiers and furnish them with 2 rifles each. These twenty-five men may, by holding a shell hole or a section of trench, decide a battle that will decide the war in our favor." Another advertisement encouraged readers to "decide the minimum you need to live on, and invest the rest in bonds." Dr. Augustus P. Hauss, director of sales for Floyd County, sponsored fund raising drives throughout the city, and this British Mark IV tank was in New Albany on "Liberty Day," April 26, 1918, as part of his effort to entice New Albanians to buy the bonds. The drive was a success, and during Fourth of July festivities at Glenwood Park that summer, Judge John H. Weathers presented the city with a "Third Liberty Loan" honor flag in recognition of the community's effort during the drive. (Courtesy the Cody Collection.)

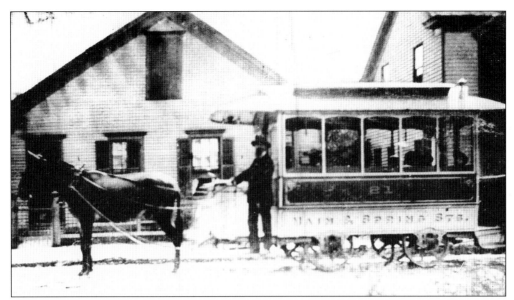

SCHOOL BUS. This is the typical school bus for those children who lived too far away from their schools to walk to classes in 1889. This particular bus collected and delivered children along Main and Spring Streets. (Courtesy the Cody Collection.)

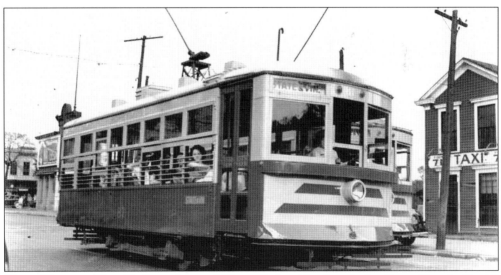

HOME TRANSIT NO. 87. One of several Birney Safety Cars bought by Home Transit, No. 87 heads west down Market Street on September 3, 1939. Designed by Charles O. Birney, the first production models rolled off the American Car Company assembly line in 1916. The cars carried 34 passengers on wicker seats in wooden frames that provided little cushion against the rough, jarring ride. Buses replaced the Birneys on January 31, 1946. (Courtesy Bill Volkmer.)

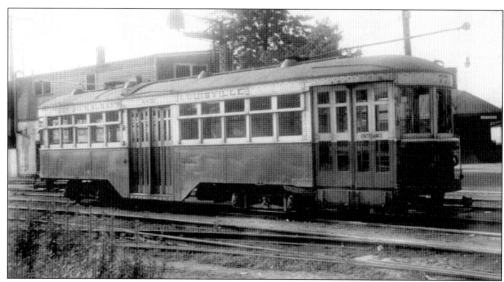

NEW ALBANY AND LOUISVILLE LINE NO. 771. Though buses had replaced the cars of the Silver Hills and Main Street lines, the State–Vincennes Street and Ekin Street lines still used electric motor cars when partners Robert R. Kelso and Raymond E. Korte bought the city line on April 22, 1934. They initially named their venture New Albany Transit, but later changed the name to Home Transit, Incorporated, known locally as the "Daisy Line." (Courtesy Bill Volkmer.)

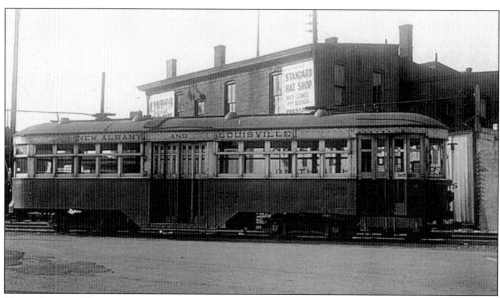

NEW ALBANY LOUISVILLE NO. 775. When Kelso and Korte started Home Transit, they immediately replaced the old wooden cars with six Peter Witt–style motorcars and four trailer cars leased from the Louisville Railway. The motorcars were numbered 770–775, the trailers 355–358. The spacious cars, all built in 1924, were immediately popular with passengers. (Courtesy Bill Volkmer.)

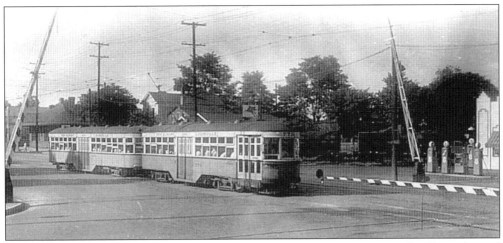

VINCENNES AND MAIN STREETS, 1940s. Car No. 773 prepares to cross the Kentucky and Indiana Bridge in this undated photograph. The cars, painted a bright canary yellow at first, were required to carry railroad style markers and an extra flagman when crossing the bridge. Trailers were used during rush hour, and the conductor on the second car usually served as the extra flagman. The color scheme changed to cream and orange in 1941. (Courtesy Bill Volkmer.)

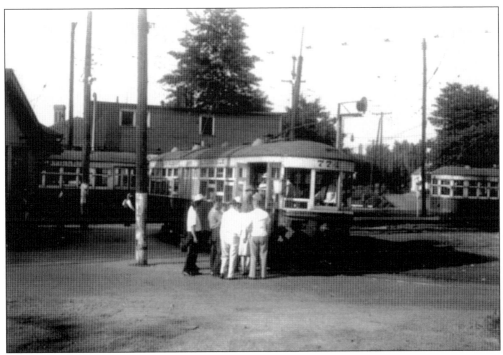

DEPOT AT MARKET AND VINCENNES STREETS. The cars normally operated on a 30-minute schedule, but during rush hour, trailer cars were added to the motorcars and service was increased to every 15 minutes. Home Transit built a new depot on Vincennes Street in the mid-1930s. Passengers board car No. 774 at the new station in this photograph from the early 1940s. (Courtesy Bill Volkmer.)

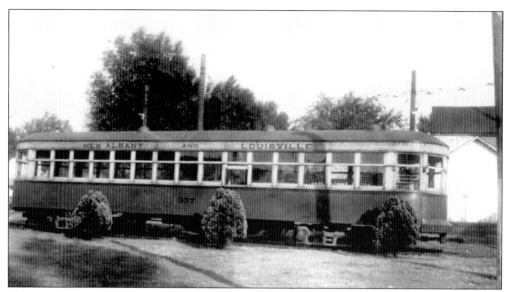

TRAILER NO. 357. The trailers were used during rush hour or on special occasions. Home Transit closed rail service between New Albany and Jeffersonville at midnight Saturday, April 21, 1934, and opened a bus line between the two cities at 5:30 a.m. Sunday, April 22, 1934. The new buses did not arrive until after the rail service closed and went into service with no trial runs, or driver training. (Courtesy Bill Volkmer.)

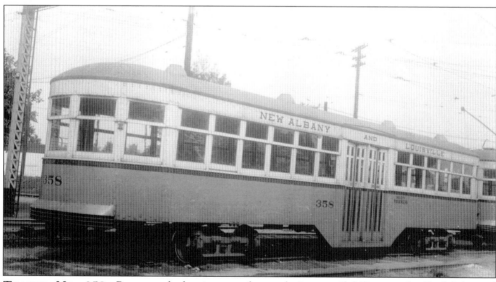

TRAILER NO. 358. Buses and the increased popularity, availability, and affordability of automobiles spelled the end of the interurban lines across America. When the population shifted from the inner city to the suburbs, Home Transit started losing money and closed the New Albany and Louisville line on December 31, 1945. The cars went back to the Louisville Railway and were used until 1948. (Courtesy Bill Volkmer.)

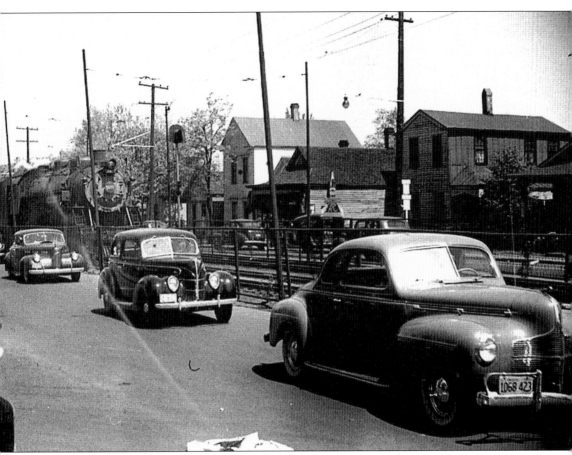

VINCENNES STREET. A train and several cars wait to cross the Kentucky and Indiana Bridge on Derby Day in 1940. In 1880, Kentucky and Indiana passed resolutions authorizing a toll bridge between New Albany and Louisville. The acts specified the bridge have roadways for pedestrians and wagons and seven turnouts on each side that allowed slower wagons to pull over and let faster traffic pass. A single railroad track was also specified. New Albanians W. T. Grant and William Culbertson were the major proponents for the project, and when the Kentucky and Indiana Bridge Company was formed later that year, Culbertson's brother-in-law, former Confederate colonel Bennett H. Young, was elected president. Construction began in 1881, and the bridge opened in 1885. Hundreds of thousands of travelers crossed the Kentucky and Indiana until the Sherman Minton Bridge opened in 1964. Crossings dropped from 75,000 to 17,000 by 1969. The toll collectors were eliminated, and an honor system for collecting the tolls failed. After a truck crash in 1979, the bridge was permanently closed to vehicle traffic.

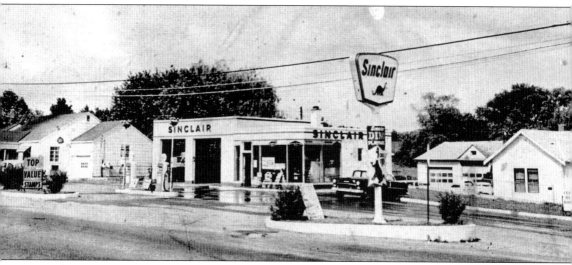

CHARLESTOWN ROAD AND KLERNER LANE. Wayne Cook owned this Sinclair station on the corner of Charlestown Road and Klerner Lane when this photograph was taken around 1958. Albert Kahl purchased the business from Cook in the early 1960s. The building was demolished in the early 1990s, and a Walgreen's Pharmacy was built on the site in 2000. (Courtesy Gwen Farnsley.)

VINCENNES STREET. The building at the far left of this photograph was the hardware store of Charles L. McGloshen when this photograph was taken from a window in the library of New Albany High School in 1940. McGloshen and his wife Virginia lived on Charlestown Road, just east of Hedden Court. H. B. Owens owned and operated a drugstore next door to the hardware store.

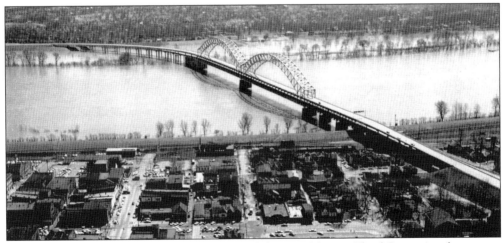

SHERMAN MINTON BRIDGE. Named in honor of Sherman Minton, Floyd County's only supreme court justice, the bridge spans the flooded Ohio River in this 1964 photograph. Discussion about the bridge began in 1957, and the span opened in 1964. Discussion for two new bridges linking Louisville and Clark County began in the late 1980s; those bridges are expected to open in 2017. (Courtesy Indiana Room.)

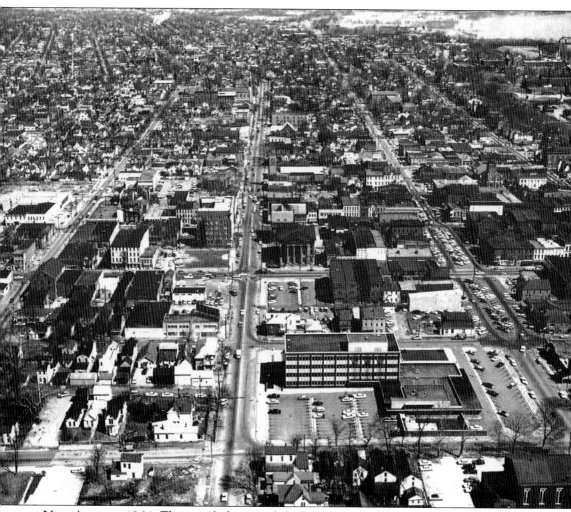

NEW ALBANY, 1964. This aerial photograph looking east on, from left to right, Elm, Spring, and Market Streets, was taken shortly before the old courthouse, seen in the center of the photograph, was demolished. The $2.45 million office complex on the bottom replaced the columned building and was named Hauss Square in honor of Dr. Augustus P. Hauss, president of the City-County Building Authority. Hauss announced on February 11, 1957, that the time was right to build modern housing for New Albany and Floyd County government. Dedication ceremonies for the new building were held on October 18, 1961. That same year, the housing authority authorized $4.5 million for additions to Floyd Memorial Hospital. Capital to fund these projects came from an annexation on August 14, 1956, that included the new Pillsbury plant and Public Service Indiana's $110 million Gallagher power plant, doubled the size of the town, and immediately added $9 million to the city's coffers, with the prospect of much more to come. (Courtesy Indiana Room.)

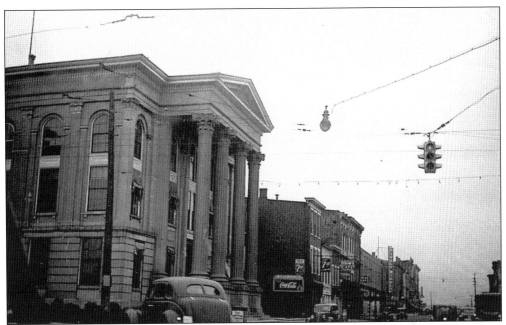

THE FLOYD COUNTY COURTHOUSE. In the spring of 1957, a reporter for the *Saturday Evening Post* came to New Albany to report on the controversial annexation the previous summer. The reporter had one major problem when trying to find the courthouse. He kept bypassing the old building, thinking it was an abandoned warehouse.

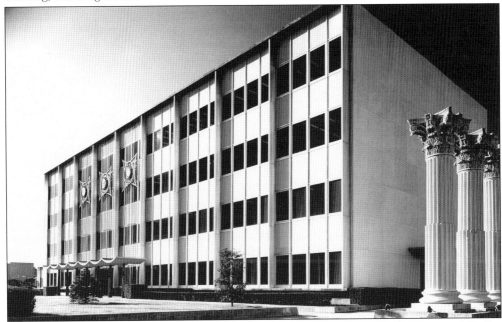

NEW ALBANY/FLOYD COUNTY CITY-COUNTY BUILDING, 1974. On February 11, 1957, Dr. Augustus P. Hauss, president of the City-County Building Authority, announced that the New Albany/Floyd County City-County Building, the first of its kind in Indiana, would be constructed on the site of the old Scribner High School. The building was dedicated on October 18, 1961. The columns on the right once graced the old courthouse. (Courtesy David Barksdale.)

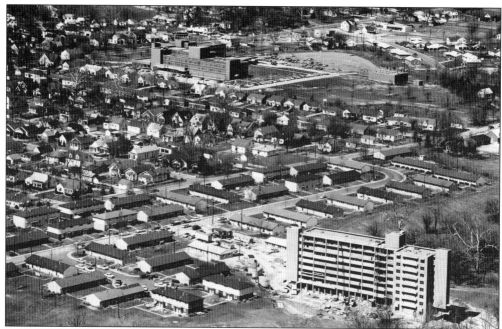

BONO ROAD AND STATE STREET AREA. The New Albany Drive-In is in the top right corner of this aerial photograph taken in the mid-1960s. Floyd Memorial Hospital is in the center, and the long, one-story structures below it are duplexes in the Bono Road Housing Project. The Parkview Towers Retirement Housing hi-rise, bottom right, was under construction. (Courtesy David Barksdale.)

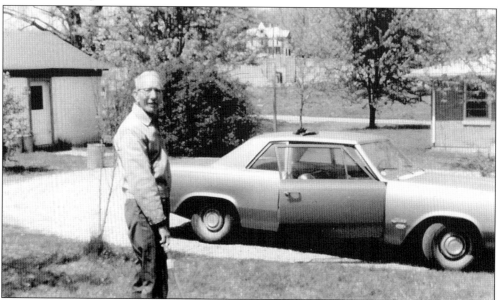

THE SOLSTEIN MANSION. Charles Gullett poses in the backyard of his brother's brick home on Grantline Road, seen on the right in this photograph from 1971. The home is currently used as the childcare center for Indiana University Southeast. The Solstein Mansion is in the background. Mary Belle Mann lived in the home with her son Frederick. The Indiana University Southeast Life Sciences Building currently occupies the spot. (Courtesy Sharon Gullett.)

Two

NEW ALBANIANS

The Past is the Land of Missing Persons, and it is only by a combination of diligence and good fortune that anyone who is not monumentally remembered can be found there.
—Hervey Allen

The enormous wealth and power accumulated over a lifetime by immigrants William S. Culbertson, C. W. DePauw, and John Ford enabled them to sculpt the landscape and shape the character of New Albany to fit their visions for their adopted city. Their influences remain stamped on the city today. Visitors can tour the Culbertson mansion, often referred to as the premier example of Indiana's Gilded Age architecture. Although the home where the richest man in Indiana once lived is currently a private residence, tourists can view DePauw's grand old mansion from the brick-paved sidewalk. Both homes tower over their neighbors on Main Street. Treasure hunters can still find chunks of green, blue, and yellow glass from Ford's American Plate Glass factory, the first plate glass manufacturer in North America, along the banks of the great river near the former site of the works.

Photographs of all three of these important and visionary men are included in several historical accounts of New Albany, and for this reason the author has purposefully omitted their pictures from the pages of this chapter. For the same reason, anyone looking for photographs of such famous New Albanians as Catholic cardinal Joseph Ritter, professional baseball player Billy Herman, or Olympic swimmer Camille Wright will need to look in one of the numerous other sources available.

This chapter contains the photographic history of the common, ordinary people proud to claim the title "New Albanian," no matter how strange the label may sound to outsiders.

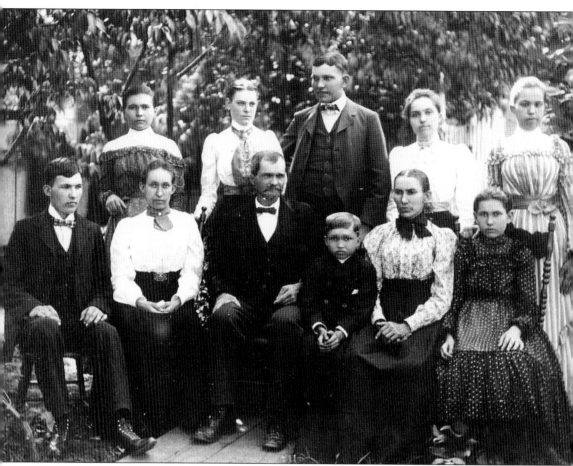

THE CHOULEY FAMILY. The Chouley family posed for this photograph in the backyard of the family home at 1419 Locust Street shortly after the beginning of the 20th century. Pictured from left to right are (first row) John Chouley, Catherine O. Chouley, Eugene Chouley Sr., Eugene Chouley Jr., Catherine Freiberger Chouley, and Anna Chouley; (second row) Francis Chouley, unidentified, Ferdinand Chouley, Elizabeth Chouley, and Emma Chouley. Catherine injured Emma's eye while trying to undo a knot in her daughter's shoestring with a fork. None of the Chouley girls married. (Courtesy Sharon Gullett.)

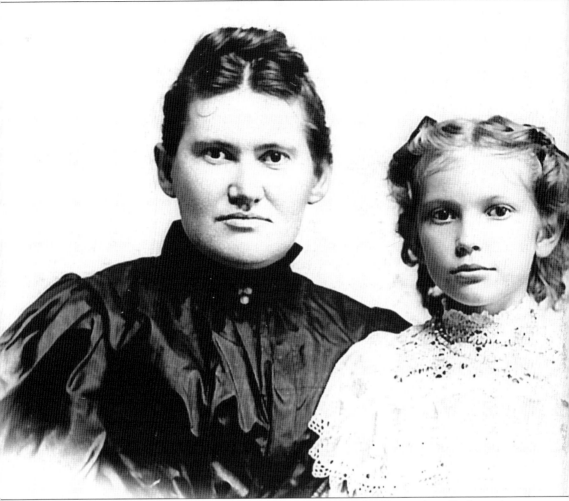

MARGARET WEEKE HEUSER AND DAUGHTER. Margaret Weeke Heuser (née Freiberger) was born on April 28, 1865, just days after the end of the Civil War. She poses with her daughter, Florence, born in 1888, for this photograph around the beginning of the 20th century. Margaret passed away in 1944, and Florence died in 1971. (Courtesy Sharon Gullett.)

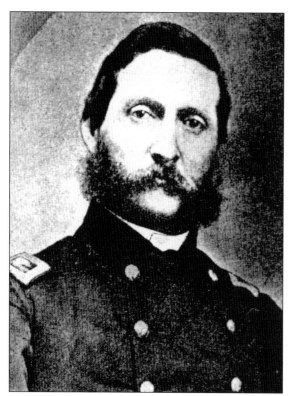

BREVET BRIG. GEN. BENJAMIN FRANKLIN SCRIBNER. Born in 1825, Benjamin Franklin Scribner was the son of Abner Scribner. He married Martha Maginess in 1849 and commanded the 38th Indiana Infantry Regiment during the Civil War. Wounded several times during the conflict, his injuries eventually forced his resignation on August 21, 1864. In 1877, he was appointed the United States Commissioner to Alaska, and after his return to New Albany two years later, became a partner with his brother-in-law in the Scribner and Maginess Drug Store until his death on December 6, 1900. (Courtesy Indiana Room.)

MARY SNIVELY. Mary Snively, the widow of Daniel Snively, died of malarial fever at her son's home in Brooklyn, New York, on October 6, 1880. Her body, accompanied by her two boys, was returned to New Albany three days later. Her daughter, Mrs. W. M. Lewis, initially planned to hold the funeral in her home on Market Street, but the funeral was held at Centenary United Methodist Church at 3:00 Sunday afternoon, October 10, 1880. (Courtesy Indiana Room.)

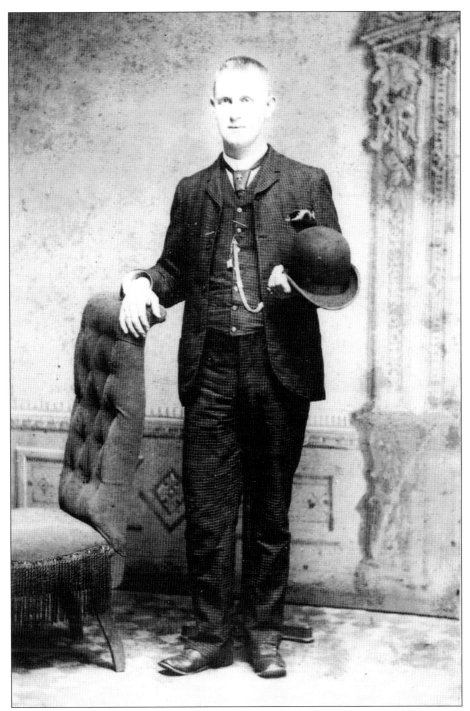

FRANK SCRIBNER. Named in honor of his grandfather Benjamin Franklin Scribner, Frank Scribner traveled from his Indianapolis home with his brothers, Edward and Richard, to attend New Albany's centennial celebrations in 1913. During the visit, Frank posed for this photograph in the studio of Wilson and Son Photographers, which was located at numbers 6 and 8 on the corner of State and Main Streets. (Courtesy Indiana Room.)

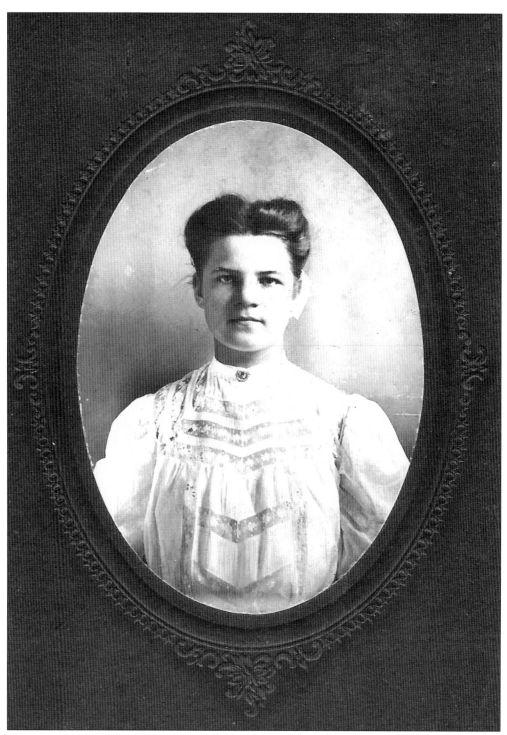

ETHEL GEIS. Ethel Geis, born in New Albany on January 14, 1889, was 16 when Abe Mann took this photograph in the studio of his Up-to-Date Photo Company located at 113 East Main Street between Pearl and State Streets in 1905. (Courtesy Janice Bilbro.)

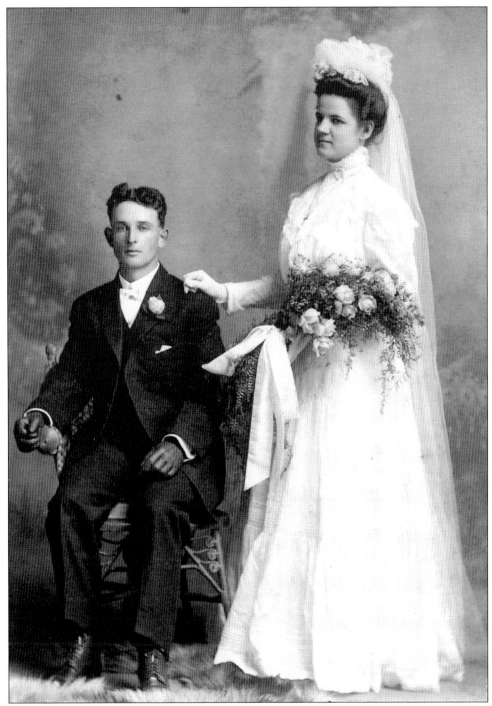

ETHEL AND CHARLES LILLY. On November 25, 1908, Ethel Geis married Charles Lilly, born in New Albany on December 3, 1887. The Lillys raised 12 children in their home on Pearl Street, and, amazingly for the time period, all 12 survived to adulthood. When Ethel died in January 1995, at the age of 105, well over 150 grandchildren and great-grandchildren survived her. (Courtesy Janice Bilbro.)

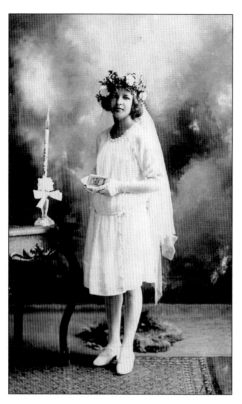

AZELIA ROSE LILLY. Azelia Rose Lilly was one of the six daughters of Charles and Ethel Lilly and instead of her flowery sounding name, was known to her close friends and family as "Dee-Dee." She poses in her confirmation dress in this photograph from around the beginning of the 20th century. Dee Dee died at the age of 72 in December 1994, and is buried in the Holy Trinity Cemetery. (Courtesy Janice Bilbro.)

AZENOR LILLY. Another of the Lilly daughters, Azenor chose the name Sister Adelaide when she entered the convent on March 25, 1916. She served in several different churches throughout Ohio, Michigan, Missouri, and Indiana during her career and died at the St. Francis Infirmary in Oldenburg, Indiana, on May 8, 1993. (Courtesy Janice Bilbro.)

DOROTHA MAY GRIMES.
Another of Charles and Ethel Lilly's daughters, Dortha May Lilly was six months old when this photograph was taken in the late 1880s. She died in May 1988. (Courtesy Janice Bilbro.)

KATHERINE KLEIN AND HUSBAND.
Katherine Klein, another daughter of Charles and Ethel Lilly, poses with her husband shortly after their marriage in the late 1920s. The Klein's lived at 1020 Pearl Street. Katherine died on September 3, 1983, and is buried in Holy Trinity cemetery. (Courtesy Janice Bilbro.)

CHARLES GULLETT. When Charles, the son of Robert Edwin Gullett and Minnie Myrtle Gullett (née Walls), was born on October 19, 1911, family legend claims that the doctor summoned to attend the birth fell out of his buggy, drunk, and broke his leg. An African American neighbor, Mrs. Brown, delivered the baby. This photograph was taken in August 1912. (Courtesy Sharon Gullett.)

BEDAINE WEDDING. Newlyweds John and Anna Bedaine posed with their unidentified bridesmaid and best man in 1920. The Bedaines lived in a home on Silver Street with their two children, Paul and Mary, until the Sunday night John stepped in front of the automobile of R. L. Kiser near the corner of Spring and East Ninth Streets. Four days later, on Thursday morning, January 26, 1933, the 51 year old World War I veteran died in St. Edwards Hospital of pneumonia and a crushed lung. No charges were filed in the accident. Anna passed away in May 1950. (Courtesy Sharon Gullett.)

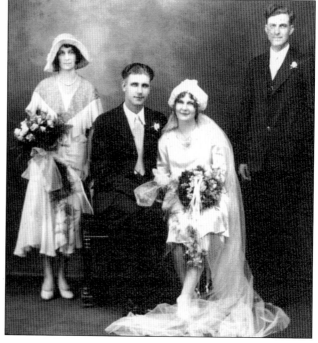

RALEIGH SUTTON AND NORMA SCHUPPERT. Norma Schuppert, right, met Gracie Kesler in the first grade at West Market Street School and married Orville Troncin on September 3, 1948, in the chapel of Wesley Chapel Methodist Church. Raleigh Sutton married Gracie Kesler in the parsonage at Wesley on August 18, 1950. Rev. W. A. Amerson officiated at both ceremonies. The pair posed in the late 1940s. (Courtesy Norma Sutton.)

GRACIE KESLER AND ORVILLE TRONCIN. The two friends posed in the backyard of a home at the corner of West Ninth and Cherry Streets in the late 1940s. The Troncins and the Suttons were the best of friends. Gracie Kesler died on September 23, 1997, and Orville Troncin passed away in July 1999. The same Reverend Amerson presided over the marriage of Raleigh Sutton and Norma Schuppert on August 18, 2001, at Wesley Chapel. (Courtesy Raleigh Sutton.)

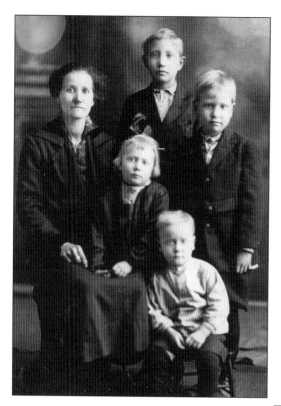

MINNIE GULLETT AND CHILDREN. Minnie Myrtle Gullett (née Walls) and her sister Winnie Wyrtle Whitten (née Walls) were the identical twins of Charney Walls and Lenora Walls (née Daniels). In 1922, the sisters had this set of photographs taken in New Albany with their children. Clockwise from the top are Charles, Morris, Edward, Alice, and Minnie Gullett. (Courtesy Sharon Gullett.)

WINNIE WHITTEN AND CHILDREN. Winnie Whitten held her daughter Evelyn Whitten on her lap as she posed with her children, clockwise from top, Bertha McCoy, Kepley Whiten, and Sherman Whitten. Bertha was Winnie's daughter by her first husband, Harry McCoy. Frank Best was the father of Winnie's four other children, not pictured—Edgar, Everett, Winona, and Eunice Anaulalee. (Courtesy Sharon Gullett.)

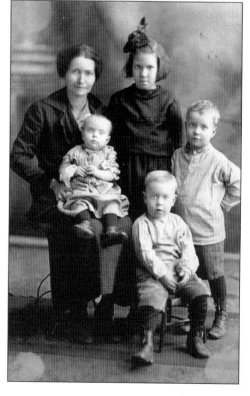

CHIEF OF POLICE. Thomas E. Spence, born in 1842, married Fanny Miller on October 15, 1875. He was a member of the New Albany Police Department from 1878 until 1913, and served as the chief in 1879. When he retired, the merchants of the town presented him with a gold medal in appreciation of his services as a member of the department. Spence died in June 1915. (Courtesy Charles Spence.)

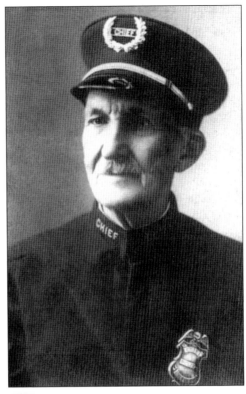

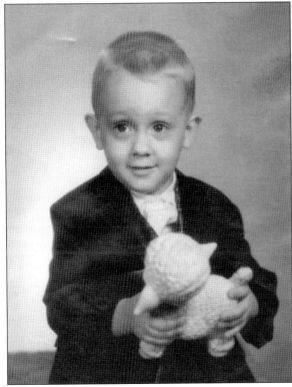

GREGG SEIDL. The author and historian is pictured in this photograph taken in the fall of 1962. Seidl, born July 21, 1960, at Floyd Memorial Hospital, graduated from New Albany High School in 1978, and joined the United States Marine Corps shortly after his graduation. A former member of the Laborers International Union of North America Local 795, Seidl is the proud parent of two children, Amelia and Zachary.

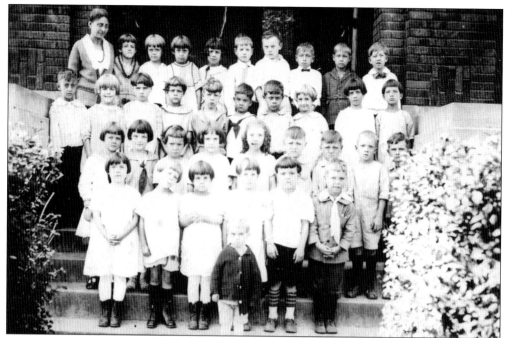

SILVER STREET ELEMENTARY. Mary Scribner, great-granddaughter of Joel Scribner, poses with her first-grade class in front of the school in 1923. Mary, called "Miss Mayme" by her students, taught at the school for 35 years. She married for the first time at the age of 80 and retired with her husband, John Rothwell, to Florida. After his death, she returned to New Albany where she died at the age of 93 on February 21, 1972. (Courtesy Indiana Room.)

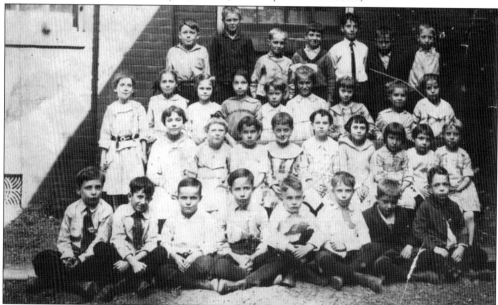

EAST MAIN STREET SCHOOL. The seriousness of the young men in the front row is balanced by the smirks of the young men standing in the rear of this photograph taken shortly before the building burned on February 20, 1919. Charles Gullett, in the back row, far right, is the only individual identified in the photograph. (Courtesy Sharon Gullett.)

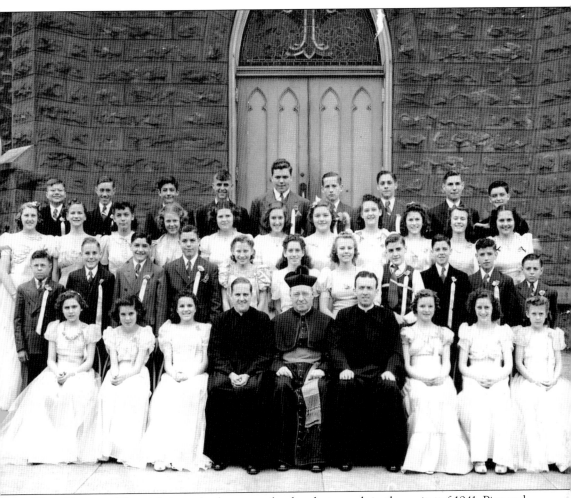

HOLY TRINITY. This eighth-grade class poses for the photograph in the spring of 1941. Pictured from left to right are (first row) Mary Lou Weber, Marie Larner, Sally Quinn, Father Carey, Monsignor Hamel, Father Marchino, Dorotha Lilly, Sarah Boutelle, and Alice Ann Hammand; (second row) Gilbert Roth, Leroy Hammitt, James Harrington, Robert Duffy, Mildred Jenkins, Mary Barksdale, Mary Jean Wannesee, George Mesinhelder, Richard Traughber, John Heaustis, and Frank Miller; (third row) Martha Ellenbrand, Mary Catherine Payton, Pearl Hammitt, Norma Speth, Joan James, Mary Moritz, Mary Lee Mickel, Barbara Read, Geroldine Ganley, Dorothy Duffy, and Patricia Gohmann; (fourth row) Larren Gardner, Charles Jenkins, Eddie Rogers, Ralph Tyler, Clyde Greenwood, James Hendricks, Bernard Bezy, Richard Loesh, and Lloyd Walk. (Courtesy Janice Bilbro.)

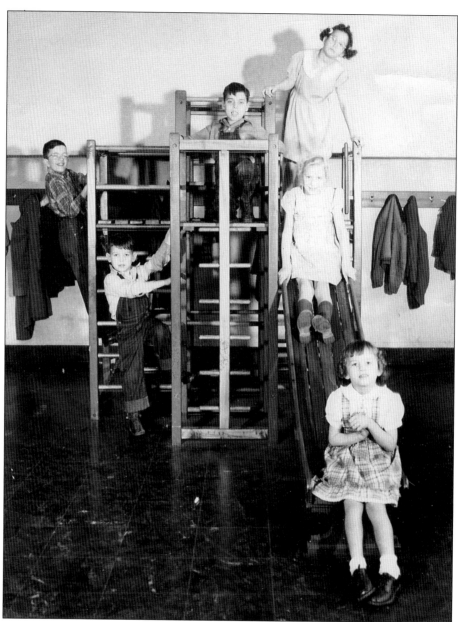

HANDICAPPED CLASS AT STATE STREET SCHOOL. Unlike the inclusion programs in contemporary education, students with any type of physical disability were placed in separate, self-contained classrooms away from their "normal" peers in the 1940s. Although the term is politically incorrect today, in 1948, such classes were labeled as "handicapped." The handicapped classes had separate restroom facilities, and lunch was served in the classrooms. Sharon Gullett, the young lady seated on the middle of the slide, suffered from tuberculosis of the spine, and was one of the students in Alice Peter's handicapped class at State Street Elementary School. Eventually released to attend classes with the "normal" students, Gullett went on to a successful career as a teacher. The other two girls on the slide are, on the top Patty Riley, and on the bottom Brenda ?. The young men are, from left to right, Buddy Spencer, Brian Mayfield, and Jerry Dowdle. The school was later renamed Lillian Emery. (Courtesy Sharon Gullett.)

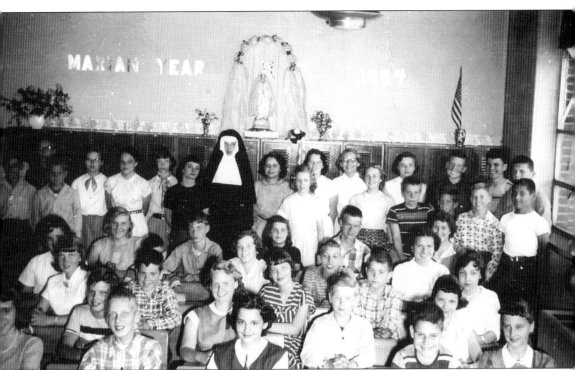

ST. MARY'S. The students in Sr. Thomas Aquinas's seventh-grade class pose for this photograph in the spring of 1954. The smiling young man standing under the flag is future Floyd County judge Larry Schad. Sharon Gullett, seated second from the left in the second row, taught mathematics as an adult at Scribner Junior High School and Floyd Central Senior High School. The other members of the class are unidentified. (Courtesy Sharon Gullett.)

Rev. George Dalrymple. In 1927, Rev. George Dalrymple became pastor of Centenary United Methodist Church. In 1928, the church began the largest remodeling project in its 90 year history. For $7,500, two restrooms were added, the front stairs relocated and enclosed, and the dome and belfry removed. Dalrymple served Centenary until his death from a heart attack on January 9, 1936. (Courtesy Centenary United Methodist Church.)

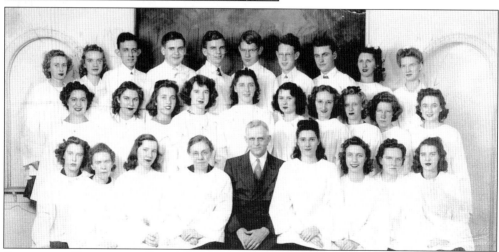

Centenary Choir, 1944. From left to right are (first row) Ethelda Trippey, Lula Mae Donihoo, Norma Leffler, Nell Edler, C. P. McKinney, Mary Alice Robison, Loretta Hall, Jessie Hall, and Dorothy Canter; (second row) Mary Helen Carroll, Wanda Mundy, Bonnie Leffler, Dolores Loweth, Margie Klosterman, Betty Manning, Hazel Kiger, Mildred Barksdale, Ruby Hall, and Marilyn McLin; (third row) Martha Shireman, Dorothy Kron, Charles Dudley, George Draper, Harold Kron, George Larson, Jim Burgess, John Prichett, Helen Payne, and Jane King. (Courtesy Centenary United Methodist Church.)

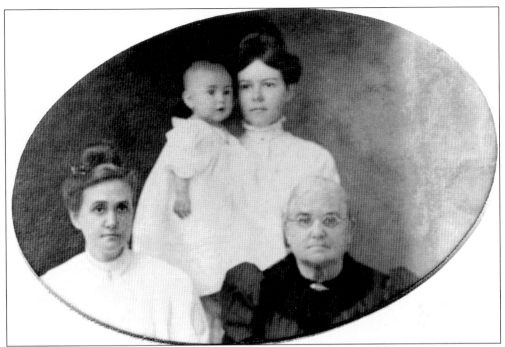

FOUR GENERATIONS. Rose McIntosh holds her daughter, Gladys Armstrong, in this photograph from 1908. McIntosh poses with her mother, Thomas Ann (Annie) Walker, seated on the left, and her grandmother, America Sanders. Unbeknownst to McIntosh, the cancer that would soon kill her had already taken hold. Gladys married Robert Armstrong in 1926. They raised their two sons, Robert Jr. and Doug, in a beautiful home in the Silver Hills. (Courtesy Robert Armstrong.)

GROUNDBREAKING AT CENTENARY CHURCH. On Sunday, May 25, 1952, Mrs. John Daniels, the oldest member of Centenary United Methodist Church, and Janice Kron, the youngest member, turned the first shovel of dirt during groundbreaking ceremonies for the Education Annex. Pictured from left to right are architect James Walker, Gladys Armstrong, unidentified, Ethel Lyons, Rev. Robert Skidmore, Byron Drumb, Rev. Arnold Clegg, architect James Hawkins, Rev. George Whitten, Robert Barksdale, Jim Wright, and Gilbert Radcliff. Walker and Armstrong were the great-grandchildren of America Sanders. (Courtesy Centenary United Methodist Church.)

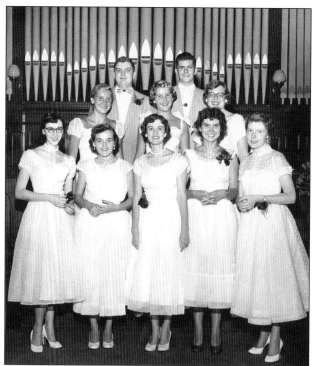

MAY 1954. These members of Centenary United Methodist church graduated from New Albany High School in 1954. Pictured from left to right are (first row) Carolyn Vance, Carolyn Thomas, Carolyn Rippy, Nancy Neely, and Carol Lynn Wilson; (second row) Ann Main, Jan Main, and Cheri Smith; (third row) Jack Eastman, and Jerry Hodge. (Courtesy Centenary United Methodist Church.)

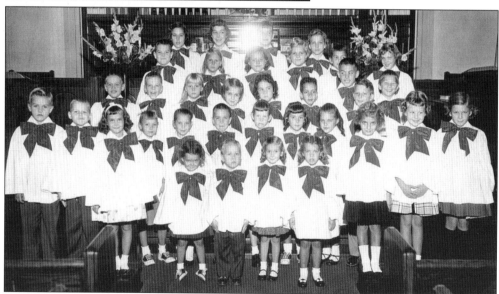

CHRISTMAS, 1957. The children of Centenary United Methodist Church pose on the church altar after their Christmas program. Pictured from left to right are (first row) Melanie Johnson, unidentified, Laura Kron, and Jane Rogers; (second row) Joel Rippy, Robin Benham, Susan Scanlon, Valerie Fothergill, Rebecca Sue Zoeller, unidentified, unidentified, Janice Kron, Jacki Manor, Joyce Eckerty, Gail Kron, and Cynthia Best; (third row) Jim Rogers, Billy Drumb, unidentified, Dottie Lester, Jan Rogers, Billy Dreschel, Joe Rogers, unidentified, and unidentified; (fourth row) Dennis Heinz, unidentified, Joy Mathes, unidentified, and unidentified; (fifth row) unidentified, Sharon Bye, unidentified, and Linda Loweth. (Courtesy Centenary United Methodist Church.)

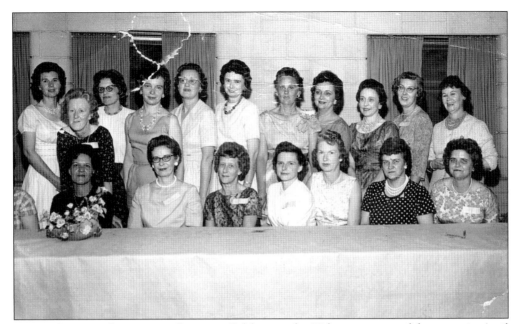

ALPHA CLASS OF CENTENARY CHURCH. Celebrating the 30th anniversary of the group, in April 1962, are (first row) unidentified, Marilyn DeLotel, Mildred Sherman, Wilma Benham, Louise Adkins, Violet Eckerty, and Miriam Richert; (second row) Marie Drumb, Martha Miller, Bonnie Hanimer, Grace Totten, Margaret Pinaire, Gwendolyn Roberson, Margaret Martin, Vilma Morlan, Dorothy Hall, and Mabel Buckel. (Courtesy Centenary United Methodist Church.)

APRIL 1965. This group of friends poses in the driveway of the home of Donald and Edith Jensen on Grantline Road in April 1965. From left to right are Chuck Freiberger, Keith Jensen, Glenn, Jim, Melvin, Janice, Duane, and Debbie Freiberger. The Freibergers were cousins of the Jensen's neighbors, Charles and Edith Gullett. The Jensen home was razed when Indiana University Southeast was built in the early 1970s. (Courtesy Sharon Gullett.)

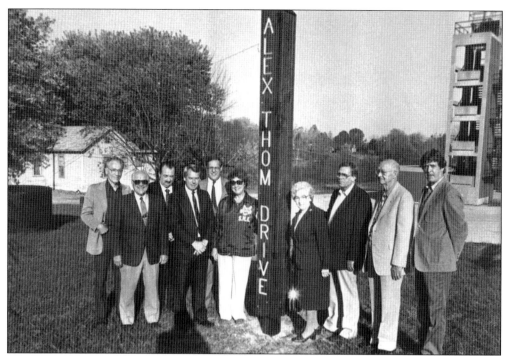

ALEX THOM DRIVE. On November 8, 1983, the entrance road into Community Park was renamed in honor of Alex Thom, a former coach and athletic director at New Albany High School. Pictured from left to right are Robert Zoeller, Garnet Inman, Bud Flynn, Jim Emery, Jerry Solomon, Lettie Walter, Jo Thom, Terry Thom, George Schrader, and Steve Norton. (Courtesy Indiana Room.)

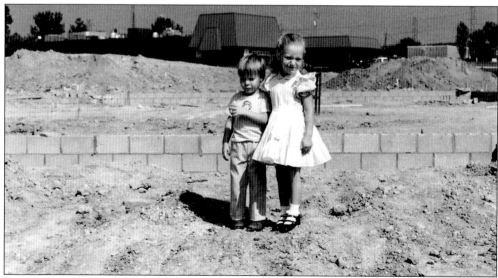

SANDY AND DAVID GLEITZ. Sandy Gleitz poses in 1987 with her little brother, David, in front of Tommy Lancaster's Restaurant on Grantline Road. The children, accompanied by their grandparents, Lamar and Virginia Miller, were attending the ceremonial groundbreaking for Northside Christian Church. Pastor Ron Wagnor held a small prayer service and then allowed each child a turn at breaking the ground with a golden shovel. (Courtesy Sandy Kirk.)

Three

WORK

Not long after he arrived in the city, Dr. John Sloan asked the name of a large, handsome man he observed laying bricks. "That's Seth Woodruff" was the answer. Later that day, he passed a building where "Judge" Seth Woodruff was presiding over a session of the court. That evening, Sloan attended a funeral conducted by none other than "Father" Woodruff, a "hard shell Baptist," who thoroughly disapproved of written sermons. The new town needed individuals with multiple abilities and skills to succeed, and the multi-talented Woodruff was typical of many of the early settlers of New Albany.

New Albanians have always exhibited a multitude of skills and talents when it came to earning their livelihoods, and everything from pastries to steamboats has been manufactured in New Albany. One of the primary reasons the Scribners first settled upon the area for the site of their new town was the enormous amount of hardwood trees covering the surrounding knobs. Boat building was one of the first major industries in the small settlement, and several factories sprang up throughout the town in the early years of the 19th century in support of the trade. When railroads ended the steamboat era, other businesses quickly replaced the lost industry. New Albany has suffered along with the rest of the nation during economic hard times, but the resourcefulness of its citizens has always saved the city from the fate of so many other small towns across the nation.

Not all of the town's residents have earned their wages in what many would consider the "normal" way. Frank Coyle spent his youth as a traveling vagabond during the Great Depression and lost his leg while trying to jump aboard a moving train. When he returned to New Albany after his recovery, "Peg Leg," as he was affectionately known, made his living shining shoes. Others have made their living in more conventional ways. Both conventional and unconventional are pictured on the pages of this chapter.

EAST MARKET STREET SCHOOL. This unidentified teacher, who poses with his fifth-grade class in front of the East Market Street School sometime in the early 1920s, was probably glad to know that, according to Edmund Burton Walker, he was "about to receive a fairly good salary." Walker, born on April 8, 1861, graduated from the New Albany Business College and began teaching in 1880. He was the principal of West Union School in 1893, and upon his retirement in 1920, he made the following comments: "It is a great satisfaction to find . . . that the people are beginning to look upon teachers as human; that we can eat and try to live very much like other workers . . . teachers at last are about to receive fairly good salaries . . . not so long ago . . . anyone choosing to become a teacher . . . was not expected to receive much remuneration; his services were to be offered as a sacrifice; his pay . . . to be in the form of personal glory from molding the minds of children. Today, however, the people realize that teachers are entitled to fair pay just like any other worker. It is a great satisfaction to know your services are worth while and are appreciated." Walker died on July 20, 1921.

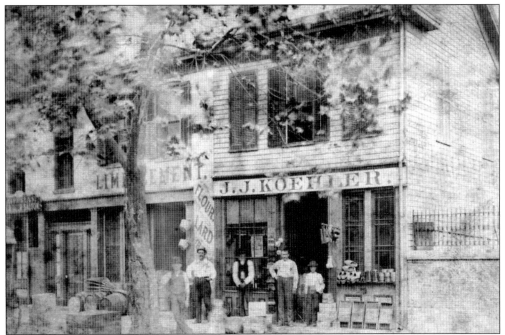

AT 414 STATE STREET. J. J. Koehler opened his store at what was 140 State Street directly behind the old Floyd County Jail. New Albany has changed the way its streets are numbered at least three times, which presents a challenge to anyone researching the location of the businesses and homes of yesteryear. The individuals standing in front of the store are unidentified in this undated photograph. (Courtesy David Barksdale.)

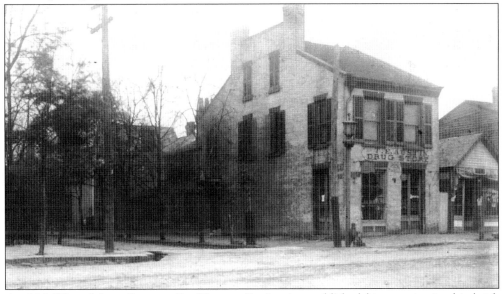

AT 226 WEST MAIN STREET. Dr. Thomas R. Austin established his practice in this brick building in 1857. His son, Thomas E. Austin, married Mary T. Rucker and joined his father in the business in 1858. Thomas R. died in 1884, and the T. E. Austin Drug Store remained open until Thomas E.'s death in May 1913. Built by Clement Nance Shields, the building stood where Interstate 64 currently bisects New Albany. (Courtesy the Cody Collection.)

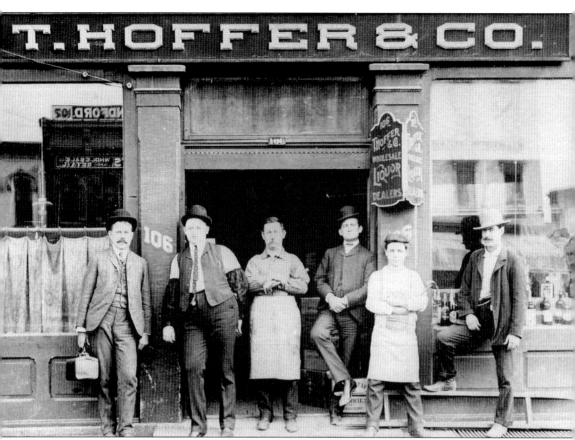

AT 106 EAST MARKET STREET. Thomas Hoffer opened a wholesale liquor company on East Market Street, and in July 1884, the *New Albany Daily Ledger* reported: "Mr. Tobe Hoffer was standing in front of his father's store this afternoon when James Mann walked across the street and used some insulting language to young Hoffer and then struck him. Mr. Hoffer feathered in on the young man and downed him when Mann drew a pistol, which Hoffer took away from him, and then proceeded to give him a good pounding. Mr. Hoffer's brother took him off Mann whose face was considerably bruised. Mann was fined thirty-five dollars for assault and carrying a pistol." The paper failed to report what caused Mann's assault, but perhaps he had consumed a bit too much of Hoffer's product. Andrew Michel, third from the left, and Charlie Michel, second from the right, are the only two individuals identified in this photograph believed to have been taken in 1896. (Courtesy Helen L. Baker.)

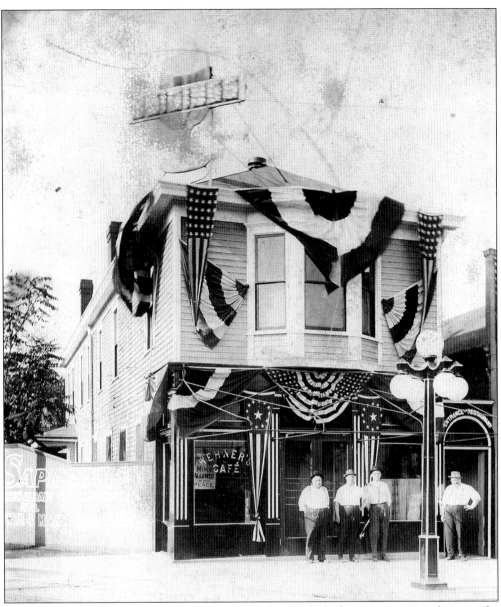

AT 1629 EAST MARKET STREET. Wehner's Café was decked out in patriotic bunting for the city's centennial celebration when this photograph was taken in 1913. Tommy Lancaster opened a catering business in the building in 1953. He eventually expanded his business to include a restaurant and bar, and New Albanians still enjoy the home-style cooking and reasonable prices of Tommy Lancaster's. The four gentlemen in the photograph are unidentified. (Courtesy David Barksdale.)

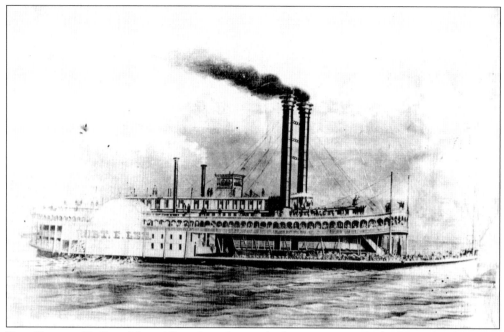

THE ROBERT E. LEE. New Albany's craftsmen had a reputation for building fast boats, so John Hancock had his *Robert E. Lee* built there. In the summer of 1870, Hancock docked his boat in St. Louis a half a day ahead of Capt. Thomas Leathers's *Natchez* in the nation's most famous steamboat race. The streamlined boat traveled the 750 miles between New Orleans and St. Louis in three days, 18 hours, and 14 minutes. (Courtesy Indiana Room.)

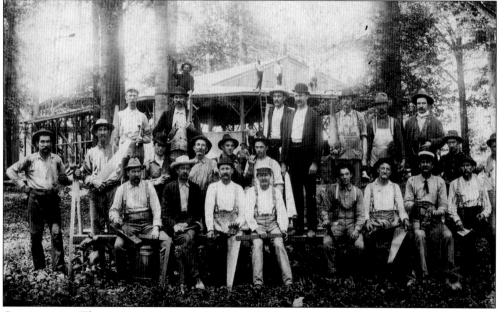

CARPENTERS. These carpenters were building the bandstand at Glenwood Park in the late 1890s and stopped their labors long enough to pose for this photograph. William P. Vaser, the gentleman in the white hat, second from the left in the front row, is the only individual identified in this photograph. (Courtesy Indiana Room.)

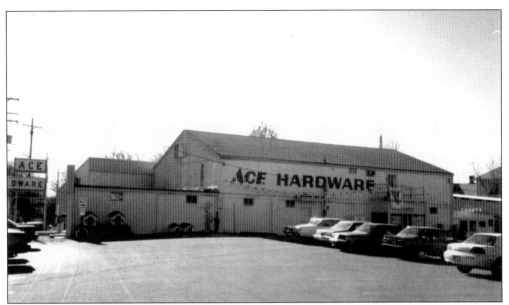

ACE HARDWARE. Paul Lee originally opened an Ace Hardware franchise on the corner of Charlestown Road and Vincennes Street in 1948. In 1950, he moved to this building on the corner of Charlestown Road and Beharrell Avenue. Paul, Jim, and Gary Staashelm run the family oriented business today, and continue to provide the same great customer service their grandfather did. (Courtesy Paul Staashelm.)

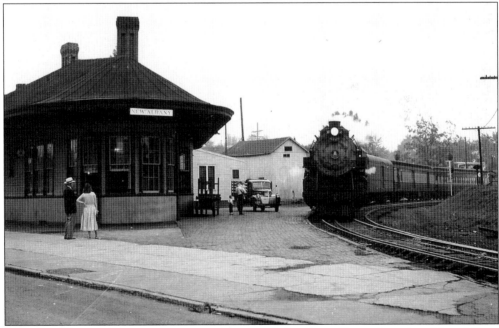

RAILROAD DEPOT. The nation was in the grip of the Great Depression when New Albany businessmen Robert Kelso and Raymond Korte bought the struggling New Albany and Louisville line on April 22, 1934. The small company outlasted all but two of the many interurban lines that delivered passengers throughout Kentuckiana. In this photograph from the 1940s, engine No. 5227 passes by the Baltimore and Ohio Railroad depot on Vincennes Street. (Courtesy David Barksdale.)

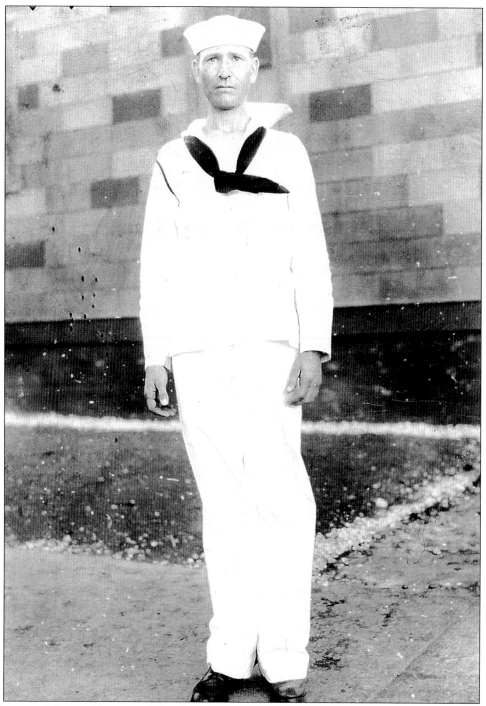

SEAMAN MORRIS GULLETT. Many New Albanians were forced to put their careers on hold when World War II began. Morris Gullett, born October 10, 1914, was the son of Robert Edwin and Minnie Gullett and volunteered shortly after the war began, but a childhood injury cut his Naval career short. His leg, broken twice in childhood, was never properly set. He died on October 22, 1993. (Courtesy Sharon Gullett.)

PFC. VINCENT FREIBERGER. Pfc. Vincent Freiberger, United States Marine Corps, posed for this photograph in 1946. Freiberger, born September 25, 1924, and his brother Wilfred joined the Marines during World War II, and both survived the war unharmed. "Connie," as his family and closest friends referred to Vincent, served as Floyd County commissioner for 20 years, and died on May 10, 1998. (Courtesy Sharon Gullett.)

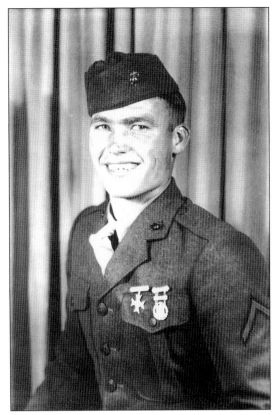

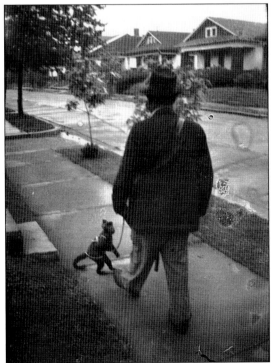

ORGAN GRINDER AND MONKEY. New Albanians have not always earned their money by traditional methods. This pair practiced their trade on the city's streets in the late 1930s and early 1940s. An unknown photographer took this picture as the twosome walked past 2107 Reno Avenue in 1939. The monkey seems aware of the photographer, but his master may have never known he was being photographed.

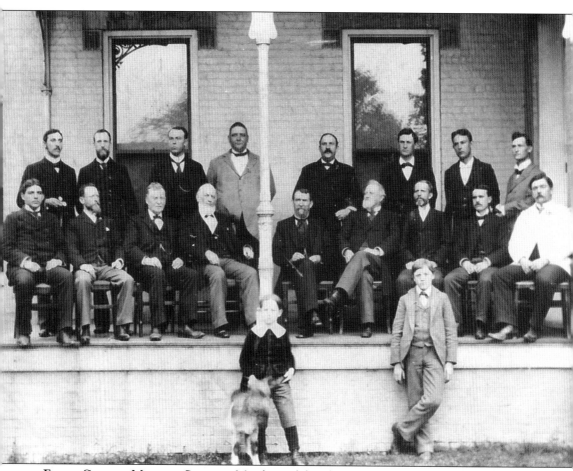

FLOYD COUNTY MEDICAL SOCIETY. Members of the Floyd County Medical Society, organized in 1878, pose for this photograph on the porch of Dr. John Hazelwood, located on the corner of East Ninth and Main Streets, in May 1897. Dr. Hazelwood's son and half-brother are the two young men standing in the front of the photograph. The other gentlemen, all doctors, are (first row) Walter King Masagana, C. W. McIntyre, William A. Clapp, John L. Stewart, Charles Bowman, Elihu P. Easlee, William C. Winstandley, and Dr. John Hazelwood; (second row) Iler Starr, W. L. Starr, J. F. Weathers, George H. Cannon, Charles P. Cook, Robert W. Harris, Frank H. Wilcox, and E. L. Sigmon. (Courtesy David Barksdale.)

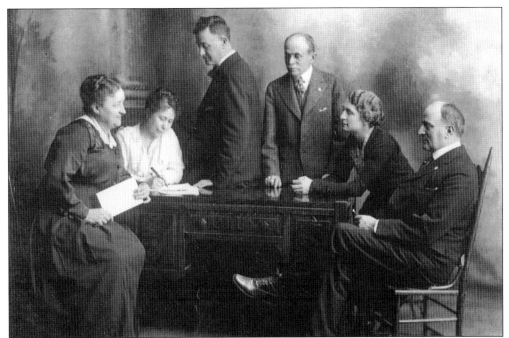

NEW ALBANY CHAPTER OF THE AMERICAN RED CROSS, 1917. The chapter formed in response to the tornado that struck the city on March 23, 1917. Pictured from left to right are Nana Young, secretary of the Civilian Relief Committee; Mrs. Charles S. Hartley, secretary; Dr. R. W. Harris, treasurer; W. B. Creed, chairman; Mrs. Charles W. McCord, vice-chairman; and E. B. Stotsenburg, chairman of the Civilian Relief Committee. (Courtesy Indiana Room.)

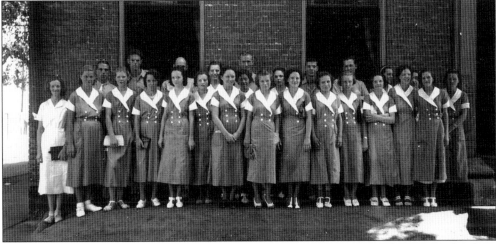

NEW ALBANY CHAPTER OF THE AMERICAN RED CROSS. Members of the chapter posed in front of their headquarters at 330 East Third Street in this undated photograph. Pictured from left to right are (first row) Audrey Gibson, Josephine Camp, Susie Muncie, Mabel Saunders, Ruby Heckler, Lois Deffinger, Helen Fulton, Wilma Murphy, Loretta Heeb, Elizabeth Sarles, Mary Amy, Geraldine Cooper, Lula Schepp, Marguerite Wright, Ruth Stephens, Sarah Jones, and Elizabeth Endris; (second row) Herb Jenkins, Kenney Bennett, Charles Vest, Bernice Calhoun, Adolph Schaaf, Byrl Rutherford, George Maymon, Vivian Frenz, and Virginia Walker. (Courtesy the late Lucille Paris.)

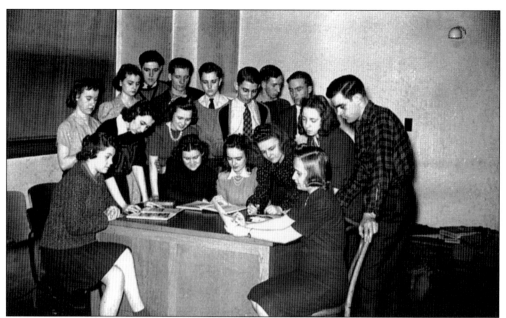

New Albany High School Annual Staff. The members of the yearbook staff were hard at work when this photograph was taken in 1940. From left to right are, (first row) Jean Finnegan, Mary Kay Belch, Evelyn Conner, Elizabeth McGauhy, and Theodora Day; (second row) Katherine Frey, Mary Lee Keith, Lois Lee Lyons, and Bill Receveur; (third row) Mary Katherine Haeseley, Verbal Garrett, Daniel Cannon, Victor Zink, Robert Oakes, Victor Soergel, Harry Mason, and Leonard Hottel.

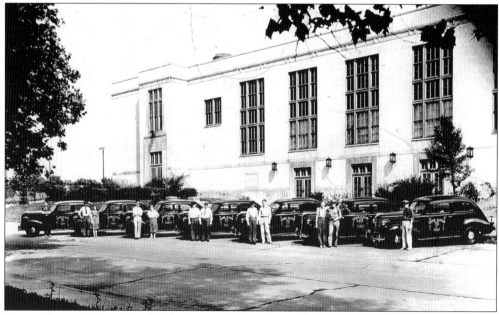

Seven-Eleven Taxi. Roy L. Marsh owned the Seven-Eleven Taxi Company, located at 410 Pearl Street in 1941. Marsh lived at the same address and poses here with his employees and fleet of vehicles on the side of New Albany High School in the early 1940s. Marsh died in October 1955. (Courtesy David Barksdale.)

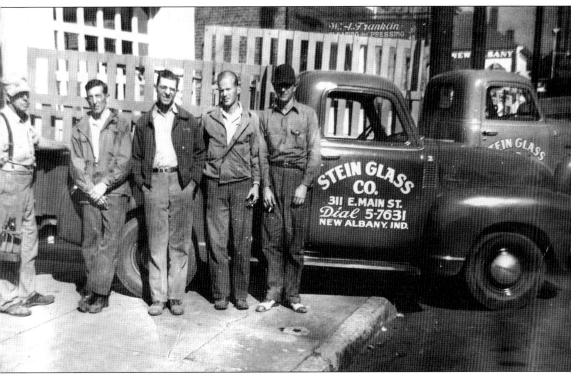

STEIN GLASS COMPANY. Deweese Stein founded Stein Glass on November 25, 1939, in a three-story brick house with a two-car garage he rented from Frank Weber for $10 a month at 315 Main Street. Stein's first company vehicle was a used pick-up truck he bought for $200, but as his business grew, he always bought new trucks and sold them when they reached 40,000 miles. Until shortly before his death on December 12, 1999, Stein opened his store every Saturday morning for customers unable to pick up their glass during the week. His son, Joseph, continues this dedication to customer service. The Steins are as dedicated to their employees as they are to their customers, and turnover among the company's work force is low; Frank and Emma Helton worked there for over 30 years. Joseph Stein plans to turn the business over to his nephews Matthew and Kyle Bir. Pictured from left to right in this photograph from 1946, when Deweese moved the business to 311 Main Street, are Oscar Stein, Melvin Peers, Deweese O. Stein, Henry Seacat, and Russell Stein. (Courtesy Joseph Stein.)

KAHL'S BODY SHOP, 1962. Albert Kahl eventually moved his growing family and automotive repair business from the cramped quarters on the corner of Charlestown Road and McDonald Lane to these more spacious accommodations on Mount Tabor Road. The garage seen in this photograph from January 1962 was surrounded as the business expanded. (Courtesy Mickey Kahl.)

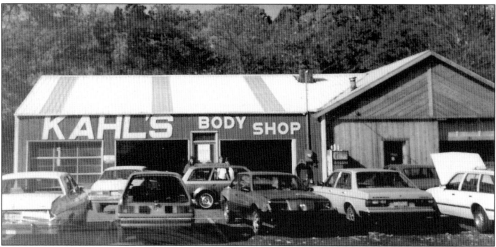

KAHL'S BODY SHOP, 1985. Four of Albert Kahl's children, Mickey, David, Terry, and Gwen, continue to provide the same quality work their father was noted for, and Kahl's grandsons Jason and Mitch Kahl, are the third generation of the family to work in the business; several cousins work there as well. Kahl's first garage is on the right of this photograph from 1985. (Courtesy Terry Kahl.)

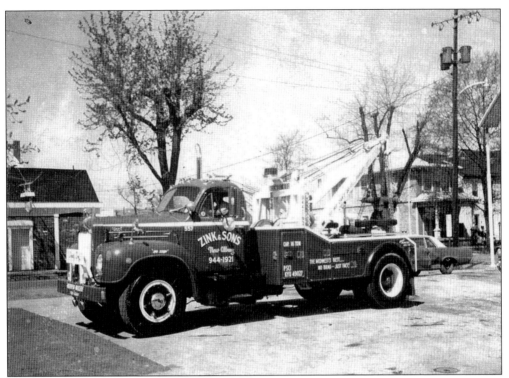

ZINK AND SON'S WRECKER SERVICE. Jack Zink opened a full service Marathon gas station on the corner of East Fourth and Spring Streets in the early 1960s. Not long after opening his garage, Zink started an automotive towing service. He expanded the towing business and specialized in hauling semi-trucks and other large equipment. This red Mack truck with white striping was one of his first big wreckers. (Courtesy Wilma Zink.)

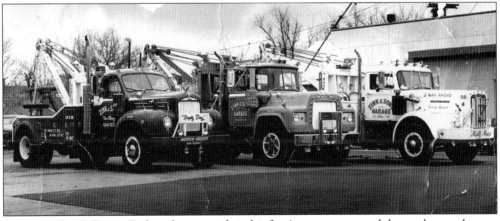

ZINK AND SON'S FLEET. Zink took great pride in his fleet's appearance, and the trucks were known for their colorful paint schemes and shiny chrome. He also named every one of his vehicles. In this photograph from the late 1960s, his original heavy wrecker, the "Deputy Dawg," is on the left, "Super Dawg" is in the middle, and "Mighty Mouse" is on the right. (Courtesy Joe Zink.)

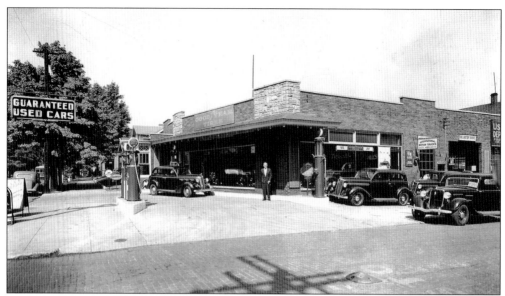

Trinkle's Automobile Repair and Sales. Morgan Trinkle stands in front of his business on the corner of Fifteenth and Market Streets in this photograph from the 1940s. Trinkle sold new and used automobiles and operated a full service garage. In the mid-1970s, Jack Zink moved his expanding business to the corner building. (Courtesy David Barksdale.)

At Fifteenth and Market Streets. Zink's Chevrolet El Camino, painted in the black and silver color scheme adopted for his wreckers during this period, sits in front of the building. Zink and Son's moved two more times over the next 20 years. Zink died in 1994, and the business closed in 1999. (Courtesy Joe Zink.)

Four

ENTERTAINMENT

New Albany has always provided residents and visitors with ample opportunities for amusement. Some New Albanians spent evenings relaxing in the refined atmosphere of the luxurious Opera House on Spring Street; others enjoyed locally brewed beers in the smoky interiors of one of the several pool halls and bars scattered throughout the city. Today the former Opera House is an office building, but patrons of the fine arts can still spend an enjoyable evening at the Ogle Theater on the Indiana University Southeast campus, and beer connoisseurs are satisfied by the New Albany Brewing Company at Rich O's Pub, conveniently located just east of the college.

New Albany has been home to hundreds of social clubs and organizations. Several prominent citizens were allegedly members of the Knights of the Golden Circle, a secret group of Confederate sympathizers, but others filled the ranks of the Grand Army of the Republic, an organization composed of Union veterans of the Civil War. Today civic-minded New Albanians can apply for membership in the International Order of Odd Fellows, the Redmen, Toastmasters International, the Calumet, Lions Clubs, or one of the American Legions or Veterans of Foreign Wars located in the town.

The sharp crack of a bat making solid contact with a baseball was probably first heard in New Albany at Camp Noble, a Civil War training camp on Charlestown Road commanded by Gen. Lew Wallace, the future author of *Ben-Hur: A Tale of the Christ*. A warm spring evening at the ball park in Glenwood Park was a favorite way for many Victorian Era residents to end their workday, and the stands at the two Little League parks in the city today are usually filled with fans cheering for children playing on the same grassy diamonds where their supportive parents and grandparents spent the summer evenings of their youth. From soccer to football, and from fan to athlete, sports remain a popular pastime for many.

This chapter contains images representing but a small sample of the many ways New Albanians have enjoyed their leisure time.

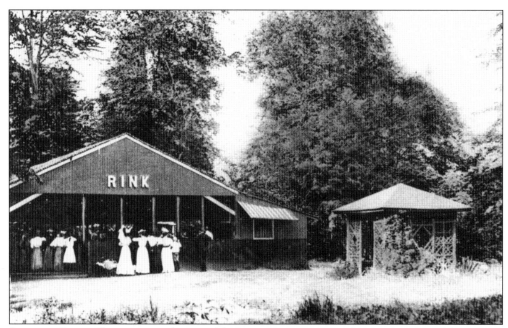

SKATING RINK. Skating was only one of the many attractions at Glenwood Park. Athletic fields, a bandstand, and natural amphitheater were all located amidst the shady groves and sunny fields of the park. Silver Creek bordered the eastern boundary of the park, and a quick dip in the cool waters of the shaded stream was a popular way to beat the summer heat and humidity. (Courtesy Indiana Room.)

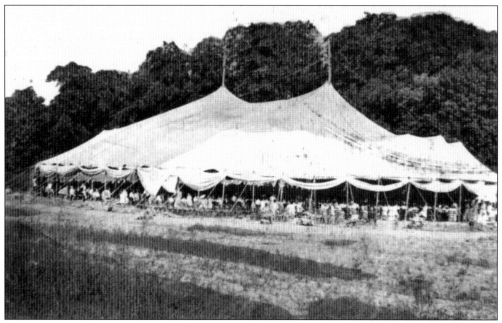

CHAUTAUQUA FESTIVAL TENT. Chautauqua festivals were held for several weeks during the humid summer months. Although the atmosphere must have been dreadfully oppressive at times, the lectures, revivals, plays, and debates held under the huge tents were always well-attended by New Albanians dressed, as fashion dictated, up to the neck in wool. (Courtesy Indiana Room.)

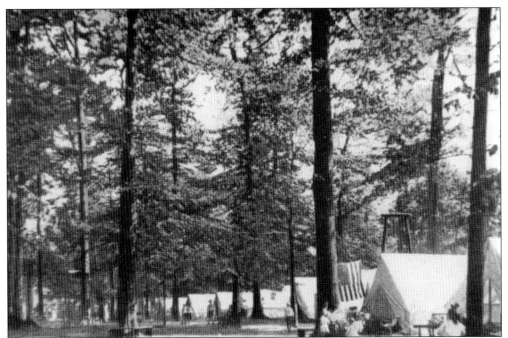

CHAUTAUQUA CAMPING. Families spent weeks living in large canvas tents amidst the tall trees of Glenwood Park during the annual Chautauqua celebrations in the early 20th century. Besides the nightly lectures and plays, sporting events and other entertainments took place during the four- to six-week festivals. (Courtesy Indiana Room.)

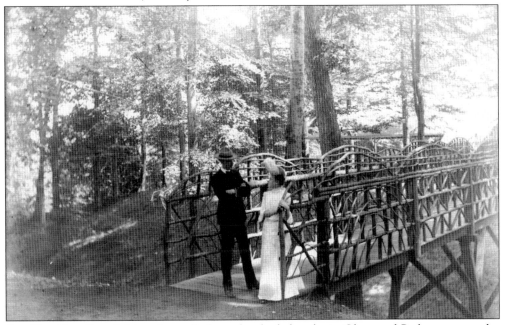

SHE HAS HER SAY. A leisurely stroll along the shaded paths in Glenwood Park was a popular way to pass an afternoon. Harvey Peake and his unidentified companion pause in this post card photograph from the early 1900s titled *She Has Her Say*. Hopefully what she said was sweet. (Courtesy Indiana Room.)

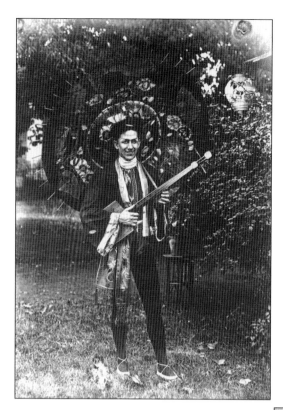

NANKI-POO. Wilbert Embs posed dressed for his role as Nanki-Poo in the Summer Opera Company production of the comic opera *The Mikado*, which began a three-day run in Glenwood Park on June 30, 1909. The *New Albany Daily Ledger* claimed Embs, the star tenor of the production, had "a voice of pleasing quality and an easy stage manner." (Courtesy Indiana Room.)

KOKO. Earl Hedden directed the performance and starred as KoKo. E. G. Barrow was stage manager, and Karl Schmidt, Charles Letzler, and Victor Rudolph were among the musicians conducted by Kirk Hedden in a performance the *New Albany Daily Ledger* claimed, "was one of the finest by home talent ever witnessed about the Falls [*sic*]." The paper described Carl Neutzel's portrayal of Pooh Pah as "impressive." (Courtesy Indiana Room.)

YUM-YUM, PITTI-SING, AND PEEP BO.
The audience packed the open-air
amphitheater for the premier
performance on Wednesday evening.
The *New Albany Daily Ledger* review
continued: "Miss Virgie Rice as
'Yum-Yum' gave new evidence of her
exceptional gifts as a singer and actress,
and gave the part a charm and grace
most captivating." Pictured from left to
right are Rice, Ethel Anderson as
Pitti-Sing, and Annie Owen as Peep Bo.
(Courtesy Indiana Room.)

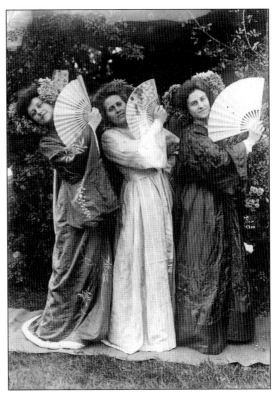

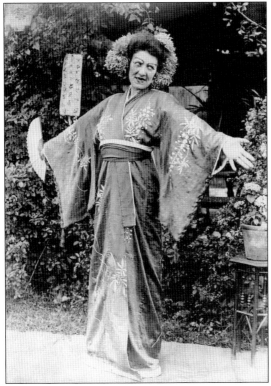

KATISHA. Bertha Schuler Van Pelt, the
wife of R. K. Van Pelt, portrayed Katisha.
The *New Albany Daily Ledger* reported
her performance "was as horrific as one
could desire and full of the grotesque
malevolence which is supposed to
characterize that great man hunter." Van
Pelt signed the back of this photograph,
"Dear Schuley, That you may ever
gaze on my hallowed charms. Katisha."
"Schuley's" identity remains unknown.
(Courtesy Indiana Room.)

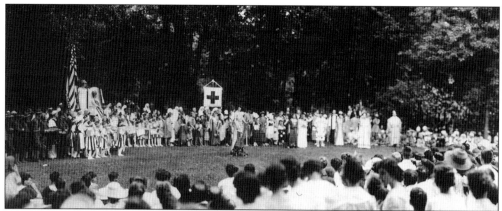

GLENWOOD PARK. On July 4, 1918, thousands gathered in Glenwood Park. Elizabeth Heib described the scene in the *New Albany Daily Ledger*: "The huge trees with their entwining branches growing in a semi-circle enclosing the grassy stage and the further bank of Silver Creek added to the background; then the hillside for 3,000 seats in front made an amphitheater to stage the 'March of Democracy,' written and directed by Professor C. B. McLinn, principal of the New Albany High School." (Courtesy the Cody Collection.)

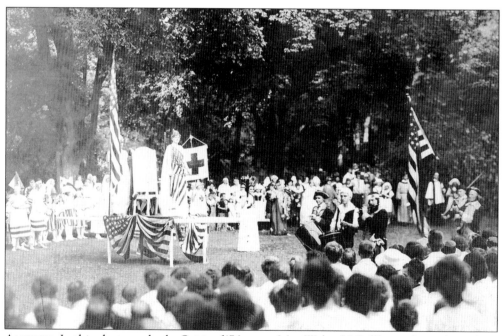

AMERICA. In this photograph, the Spirit of '76 passes Mrs. Walter V. Bullheit, who, in her role as America, proclaims, "From Bunker Hill to Yorktown plain, the tale of freedom runs. The snows of Valley Forge are stained with blood of my brave sons. The bell that then rang out the news of Liberty's new birth proclaims Autocracy's downfall." (Courtesy the Cody Collection.)

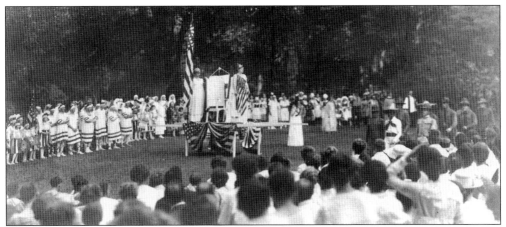

SPANISH-AMERICAN WAR. E. V. Knight, W. B. Creed, and Huston Mitchell were three of the New Albany veterans representing the Spanish-American War. Accompanied by two unidentified individuals representing Cuba and the Philippines, the former soldiers and sailors marched past America and Liberty while the band played "A Hot Time in the Old Town Tonight." Representing the Civil War was a Union officer accompanied by a squad of soldiers leading a manacled slave. When they neared the stage, the officer ceremoniously struck off the manacles with his sword, and the grateful slave fell to his knees with upraised hands. (Courtesy the Cody Collection.)

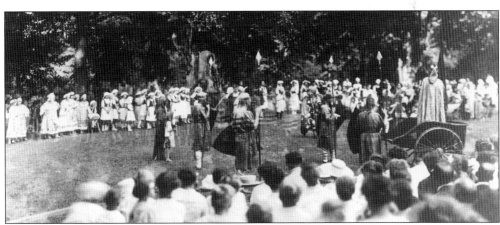

AUTOCRACY. Autocracy, his chariot surrounded by War, Death, Famine, Pestilence, Fire, Rapine, and Terror, addresses the crowd. The parts were portrayed by Harry Pierce, Walter V. Bullheit, Mayme Russell, Norman Richie, Thomas O'Donnell, Byron W. Hartley, and Dr. Noble Mitchell. T. E. Crawford and committee began selling 2,000 tickets for the event in the lobby of the Elsby Building at 9:00 a.m. on Saturday, June 29, 1918. (Courtesy the Cody Collection.)

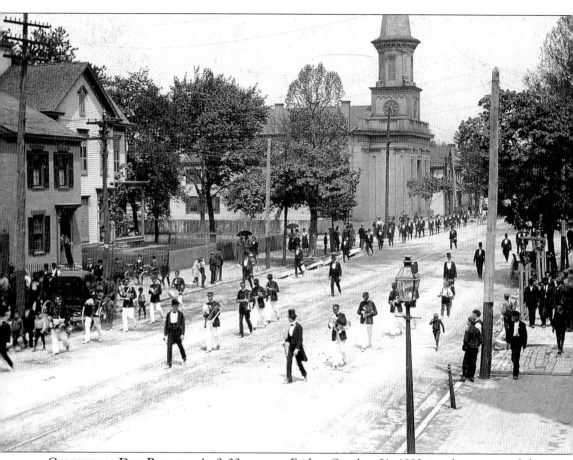

COLUMBIAN DAY PARADE. At 2:00 p.m. on Friday, October 21, 1893, in observance of the 400 year anniversary of Columbus's landing in North America, two platoons of the city police force led a mile long procession from the corner of Fourth and Spring Streets on a winding route over the city's streets. Frank A. Kraft, George H. Koch, Frank Weissinger, Daniel Walsh, and John Beaucord assisted chief marshal John P. Flynn. Participants included the New Albany Silver Band, members of the Sanderson and Robert F. Sage posts of the Grand Army of the Republic, the Catholic Societies of New Albany, a division of the Ancient Order of Hibernians from Jeffersonville, and several hundred school children waving American flags. Mayor Broecker, the city council, and other city officials rode in fancy carriages, and over 400 men from the county's outlying Catholic parishes rode along on horseback. Most businesses closed for the parade, which ended with speeches and a musical program at the Opera House on Spring Street. The procession passes Centenary United Methodist Church in this photograph. (Courtesy David Barksdale.)

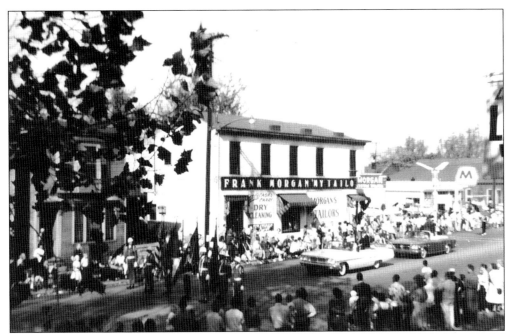

PARADE. New Albanians have always loved a good parade, and this one in the early 1960s did not disappoint them. A color guard from one of the many Veterans of Foreign Wars in the city paused on Spring Street just west of East Fourth Street. The Marathon station on the right was owned and operated by Jack Zink. Zink owned one of the largest wrecker services in southern Indiana when he died in 1994. (Courtesy the Cody Collection.)

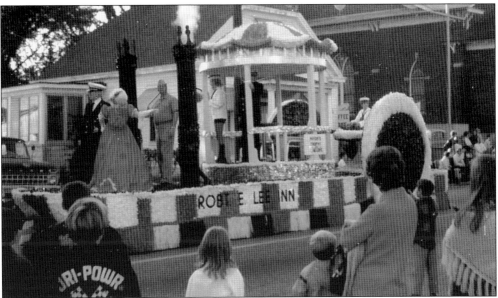

HARVEST HOMECOMING PARADE. The Robert E. Lee Inn float passes DePauw Memorial Church on Vincennes Street in this photograph from October 1971. The theme for the inn's float was, appropriately, the New Albany-made steamboat, the *Robert E. Lee*. The original boat performed much better than the mock-up; a malfunction in the machinery meant that only one stack on the float belched smoke. (Courtesy Sharon Gullett.)

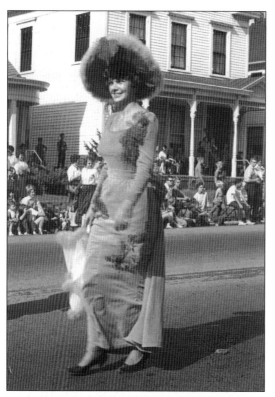

SESQUICENTENNIAL PARADE. Caroline Watkins was the leader of the High Steppers, a twirling group sponsored by the New Albany Parks and Recreation Department. She and her group high stepped down Spring Street during the parade on October 1, 1963. The parade, celebrating the 150th anniversary of the town's founding, was the forerunner for the annual Harvest Homecoming Parade enjoyed by residents today. (Courtesy Indiana Room.)

HARVEST HOMECOMING PARADE. One of Jack Zink's massive Peterbilt wreckers prepares to pull the "Bob Real for Mayor" float in a Harvest Homecoming Parade in this photograph from the early 1980s. Every time Real ran for mayor, Zink campaigned for him, and every time Real was mayor, Zink and Son's was awarded the city wrecker contract. (Courtesy Joe Zink.)

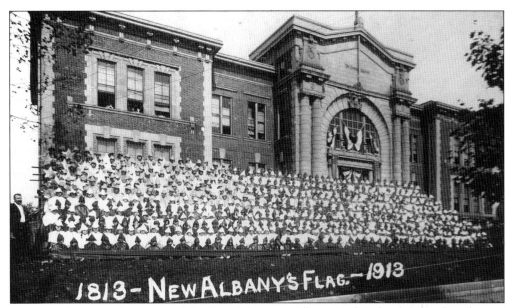

PEOPLE'S COLLEGE. Students and faculty of the New Albany High School, located in the 500 block of East Spring Street, formed an American flag in front of the school in honor of the centennial celebration in 1913. The building served as the junior high school when the new high school opened on Vincennes Street. The building was demolished in the early 1960s. (Courtesy David Barksdale.)

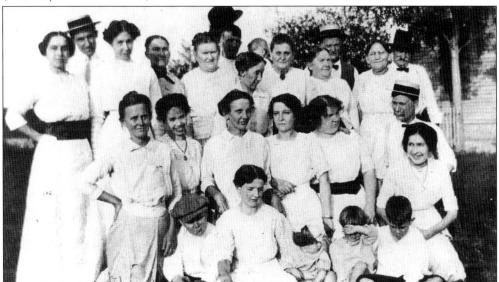

FREIBERGER FAMILY REUNION. August and Emma Jacobi hosted the Freiberger family reunion at their home on Slate Run Road in 1913. Pictured from left to right are (first row) Melvin Fenwick, Evalina Ridge Freiberger, Blanche Freiberger, Catharine Freiberger, and Harry Freiberger; (second row) Emma Jacobi, Emma Chouley, Catharine Freiberger, unidentified, Ella Fenwick, and Francis Chouley kneeling in front of an unidentified gentleman; (third row) Elizabeth Chouley, unidentified, Anna Chouley, Kate Chouley, Margaret Houser, August Jacobi, unidentified, Anna Fenwick, Magdalena Hornung, William Fenwick, Catherine O. Chouley, and Vincent Hornung. (Courtesy Sharon Gullett.)

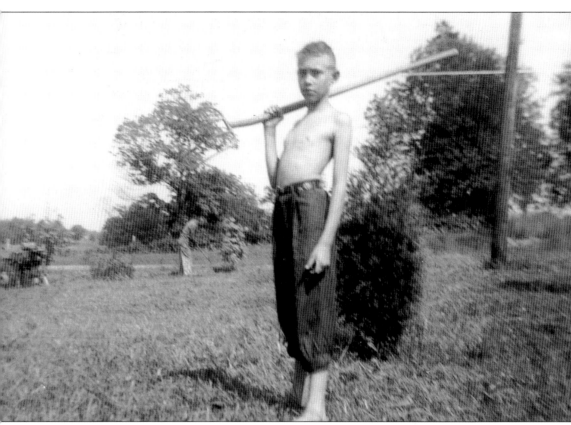

BATTING PRACTICE. Baseball is a favorite pastime of many New Albanians, both young and old, since it's introduction to the city in the early 1860s. If a real bat and ball aren't available, most young men have never had a problem batting at rocks with an available stick. Wayne Gullett poses with a rock in one hand and his "bat" slung jauntily over his shoulder in the backyard of his family home on Grantline Road in this photograph from the early 1950s. (Courtesy Sharon Gullett.)

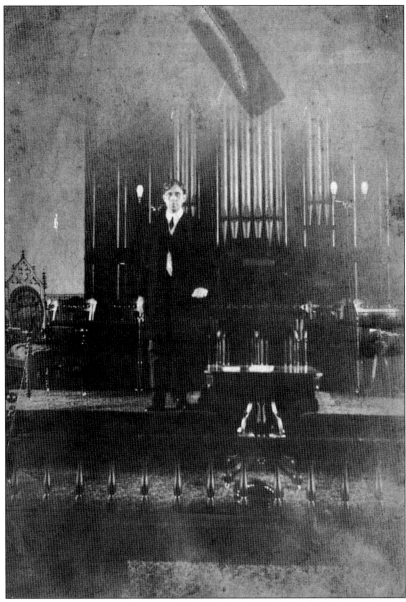

CENTENARY UNITED METHODIST CHURCH ORGAN. Rev. W. F. Smith stands in front of the organ in Centenary church in 1900. The organ was hand pumped by two boys paid $1 a month, and Allan Briscoe and Boyd Pilling were the last pair to perform this duty. Services originally did not include music, but in 1869, Rev. James Hill asked for an organ. The church authorities, after a lengthy and sometimes heated debate, agreed to the instrument, but only if those in favor of the organ paid for it. When Alex Hunter furnished a small melodeon, those opposed claimed Centenary United Methodist Church had been bought and sold for $65. Placed in the gallery at the south end of the church, the organ was used infrequently, but by 1876, most of the members opposed to music during services had either died or withdrawn from the congregation, and the organ was moved to the north end of the church. The instrument's powerful bass lows and crystalline highs accompanied worship services until the organ was removed during extensive renovations to the building in the late 1990s. (Courtesy Centenary United Methodist Church.)

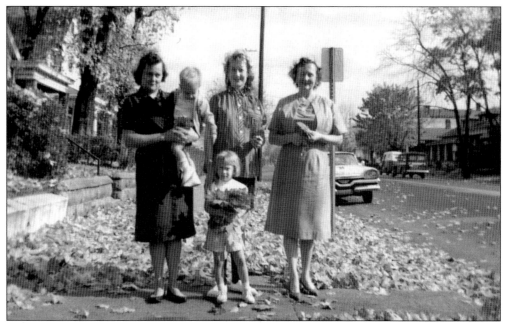

OCTOBER 1961. This photograph was taken in the fall of 1961 and looks east down Spring Street from Vincennes Street. Martha Fothergill holds her grandson Gregg Seidl, and Bonita Bryant stands in front of her mother, Joyce Bryant, who is standing next to her mother, Pauline Sweet. Sweet and Fothergill were sisters. The Bryant's lived across the street from where this photograph was taken. (Courtesy Janet Armstrong.)

HUGH E. BIR'S. Pete Hess operated a café and bar on the corner of Market and East Fourth Streets until June 1966 when Hugh E. Bir Sr. bought the building. Bir continued the café and bar until his retirement in 1988 when his son Hugh E. Bir Jr. took over the business. Bill Hanka once sold used cars directly opposite the building. (Courtesy Rachel Rice.)

ELKS CLUB THEATRE. On Sunday, March 17, 1940, 15¢ bought New Albanians a ticket for the double feature at the Elks Club Theatre on Pearl Street. *The Swiss Family Robinson* and the new Laurel and Hardy comedy *The Flying Deuces* were on the bill. Ticket buyers also watched *News of the World* and *Overland with Kit Carson.* After a disastrous fire in the early 1960s, the theater was removed.

SPRING STREET. Winona Best and her husband, Ted Bowers, pose astride Bowers's Harley-Davidson on Spring Street sometime in the late 1930s. The Elsby Building is on the far right of the photograph, and Harold's Wrecker Service occupied the garage on the left. (Courtesy Sharon Gullett.)

"RIDING ALONG IN MY AUTOMOBILE." For many New Albanians, a leisurely drive through the rolling knobs surrounding the city is an enjoyable way to spend a lazy Sunday afternoon, and several generations of the city's younger citizens spent Friday and Saturday nights cruising Spring Street between White Castle and Frisch's Drive-In restaurant. The White Castle is still on the corner of Vincennes and Spring Streets, but Coyle Dodge occupies the former site of Frisch's. Wayne Gullett was as clean as his Chevrolet when he posed for this photograph in the late 1950s. (Courtesy Sharon Gullett.)

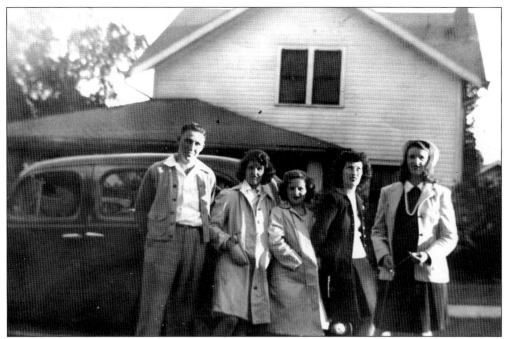

FALL FASHION, 1940s. This group of friends posed after an afternoon spent touring around the Floyd County countryside in the early 1940s. Dorotha Lilly, standing in the center, is the only person identified the photograph. Her friend, known only as Tater, stands second from the left. Fritz ? is the gentleman on the left, and the other two are identified simply as Stella and Jane. (Courtesy Janice Bilbro.)

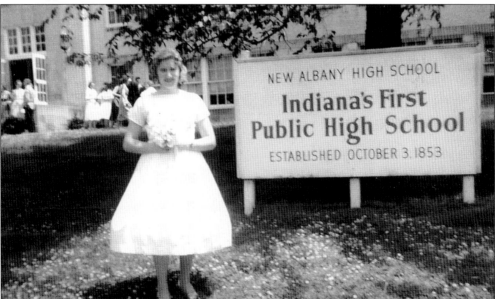

CLASS DAY. Sharon Gullett posed with a bouquet of yellow flowers in front of New Albany High School on Vincennes Street in May 1959. Yellow was the senior class color that year. Gullett obtained a teaching degree from Indiana University and taught mathematics for over 20 years. (Courtesy Sharon Gullett.)

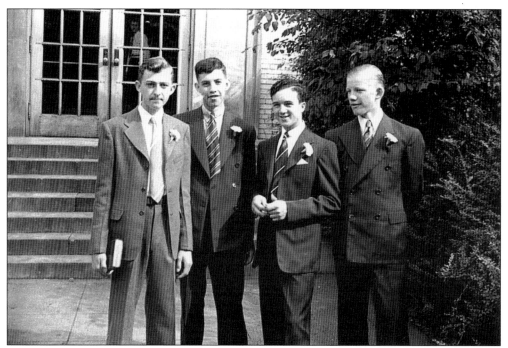

FRIENDS ON SENIOR DAY, 1941. These four friends posed in front of New Albany high school on May 23, 1941. From left to right are Austin Dietrich, Edwin Snook, Kenneth Coomes, and James Routh.

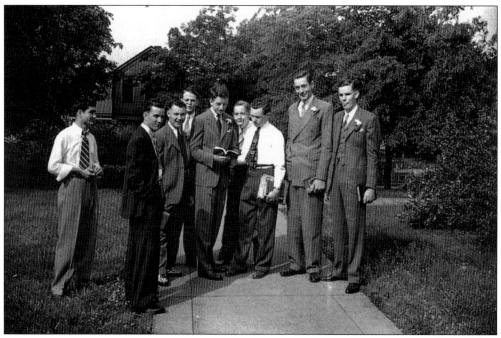

SENIOR DAY, 1941. Another group of seniors posed with Vincennes Street in the background. Pictured from left to right are George Zurschmeide, Melvin Spencer, unidentified, Charles Robinson, Robert Habermel, unidentified, Robert Stallings, John Louis Eicholz Jr., and Richard Reas.

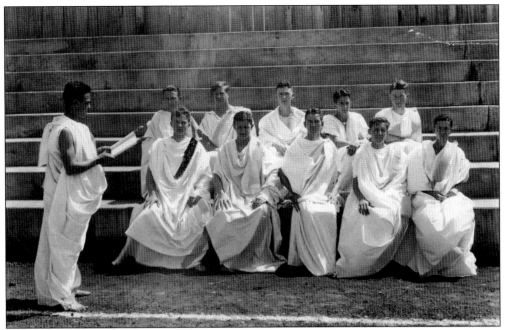

LATIN CLUB. James Ollis, barefoot on the cinder running track at New Albany High School, read to some of the male members of the Sodalitas Latina in this photograph from 1930. Among those pictured are Joseph Park, Elmer Farnsley, Donald Coyte, James Lewis, Harold Snyder, Edwin Von Allmen, Jerome Zoeller, Edward Blake, and Edmond Green. (Courtesy Indiana Room.)

REHEARSAL FOR THE SENIOR CLASS PLAY. During rehearsals for *What a Life*, James Mann, portraying the principal Mr. Bradley, points an accusing finger at Henry Aldrich, played by Harry Mason. Aldrich's love interest Barbara Pearson, played by Ida Whittinghill, looks on. The seniors staged their production on Tuesday and Wednesday nights, May 14 and 15, 1940. The *New Albany Daily Tribune* called Mason's performance, "a splendid portrayal."

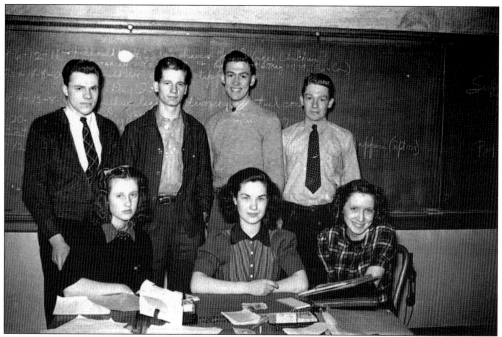

DEBATE TEAM. The New Albany High School debate team for the school year 1939–1940 poses for this photograph in the spring of 1940. Pictured from left to right are (first row) Betty Jean Seacat, secretary Ida Whittinghill, and Cecelia Ferree; (second row) president James Mann, vice-president Victor Zink, Bill Diedrich, and treasurer Bob Dean.

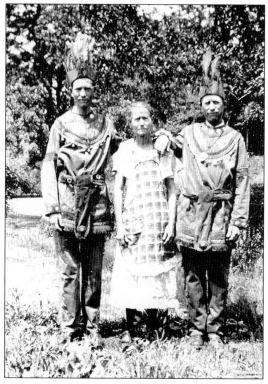

REDMEN. Many New Albanians have proudly responded to the names Redmen, Mason, and even Odd Fellow. Membership in these clubs, or in any of the numerous other social and fraternal organizations that have had chapters in the city, has always been a popular pastime. In this photograph from the 1930s, Morris Gullett (left) poses with his mother, Minnie (center), and father, Robert (right), in the backyard of his parents home at 903 Pearl Street. The men were attired in the regalia of the Redmen club. (Courtesy Sharon Gullett.)

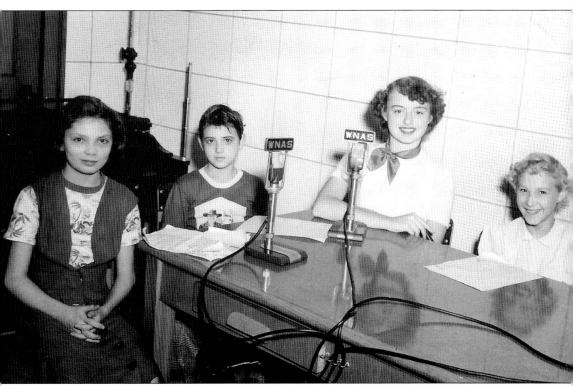

STUDIO OF WNAS. This photograph was presented to Sharon Gullett by radio station WNAS in appreciation of her participation in the radio program, *Schools are Interesting*, presented by the "handicapped class" of St. Mary's Elementary School on December 19, 1950. Sharon represented the eastern hemisphere on the broadcast. Pictured from left to right are Fern Cunningham, Irvin Bruce, an unidentified New Albany High School student, and Sharon Gullett. (Courtesy Sharon Gullett.)

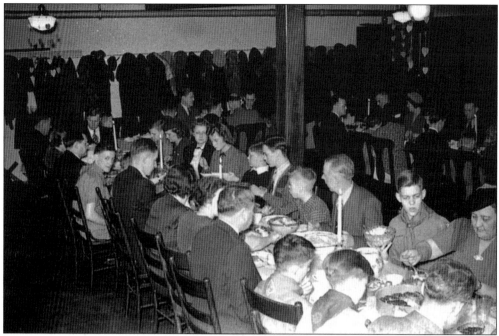

CUB SCOUT ORGANIZATION MEETING. At 7:30 p.m., Tuesday, March 5, 1940, the last of three meetings organizing the first Cub Scout packs in New Albany took place in the basement of the Central Christian Church. Pack leaders, den mothers, and assistants were named, and 72 boys enrolled in the new packs. Central Christian and DePauw Memorial Methodist Churches sponsored the packs.

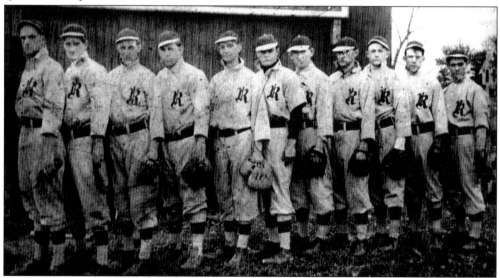

SHERMAN MINTON. The future U.S. Supreme Court justice played semi-professional baseball in New Albany in the 1920s. Serman "Shay" Minton is the first player on the left. His teammates were, from left to right, Raymond Whiteman, Charley Harmeling, Floyd Fleming, Bud Kruetzer, Jack Stringham, Dan Monihan, Fred Kepley, Peck Weaver, George Smith, and Will Proctor. Local legend claims this photograph was taken on the diamond at Glenwood Park. (Courtesy Indiana Room.)

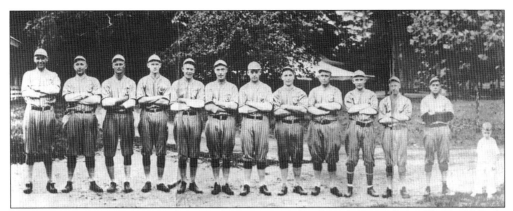

CALUMET BASEBALL TEAM. The 1921 line-up posed for this photograph in Glenwood Park. Pictured from left to right are ? Dowd, ? Eagle, ? Teske, ? Strack, ? Phillips, ? Biel, ? Stager, J. Phillips, C. Miller, C. Fleisher, "Dory" Kleiber, and two unidentified individuals. (Courtesy Indiana Room.)

BILL KERCHEVAL. Bill Kercheval, vice-president of the junior class at New Albany High School, stopped running just long enough to pose for this picture in the spring of 1940. Kercheval had a busy schedule. A member of the half-mile relay team, he played football and was in the school band and orchestra. He sang in the glee club, and was captain of the basketball team his senior year.

NEW ALBANY HIGH SCHOOL HALF-MILE RELAY TEAM. On April 27, 1940, the team set a new record of 1 minute and 35.4 seconds in the half-mile relay. One week later, on May 4, they won the 12th annual Southern Indiana Invitational meet in Petersburg. Pictured from left to right are George Zurschmiede, Bill Kercheval, Junie Zoeller, and Frank Tinias.

SHOOTING HOOPS. Bill Diedrich (left) and Buddy Ritter play on a makeshift court in the alley behind the Collin's family home at 2105 Reno Avenue. Basketball has always been popular in the city, and fans cheering their beloved Bulldogs fill the gymnasium of New Albany High School to capacity on most Friday nights during the basketball season. New Albany won the Indiana High School Basketball Championship in 1973.

BASKETBALL FESTIVAL. Approximately 4,000 fans enjoyed a basketball game between the Phillips 66 Oilers and the Marion-Kay Vanillas from Brownstown in the gymnasium of New Albany High School on January 18, 1958. The New Albany Lions Club sponsored the game, which the Oilers won 90–68. New Albany's Jojo Dean scored 15 points, but the Oiler's Grady Wallace was the game's leading scorer with 20. The game closed a day of basketball festivities throughout the city that included a clinic conducted by professional players and a player's reunion. Spring Street Junior High beat Georgetown Junior High 28–26 in double overtime in an exciting game before the main event, and former U.S. Supreme Court justice Sherman Minton presented the winning school with an award. Minton was an alumnus of the school, which was the senior high school when he graduated. Pictured from left to right in the front row are Eddie Hubbuck wearing a leather jacket, unidentified, Mary Lorch, Gertrude Minton, Sherman Minton, Chet Lorch, unidentified, Frank Lorch III, Lewis Wenzler, unidentified, and Sam Peden. (Courtesy Indiana Room.)

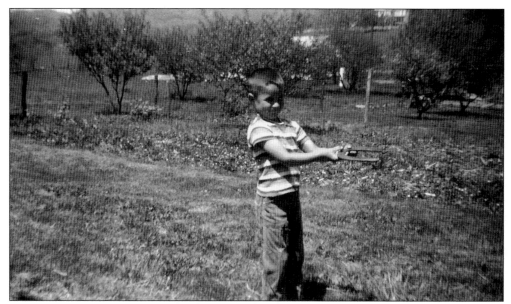

PITCHIN' SHOES. The game of horseshoes has always been a popular pastime of New Albanians. Charles (Chuck) Freiberger prepares to throw a shoe in the backyard of the Gullett family home on Grantline Road in the summer of 1965. Freiberger taught English at Floyd Central High School and was a member of the Floyd County Council for several years. He was elected Floyd County commissioner in 2000. (Courtesy Sharon Gullett.)

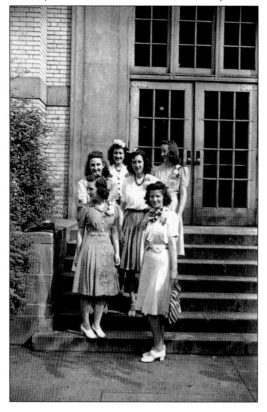

SENIOR DAY, 1941. Young men were not the only ones gathering with their friends that warm May day in 1941. This group of unidentified young ladies poses in front of the school wearing the latest fashions.

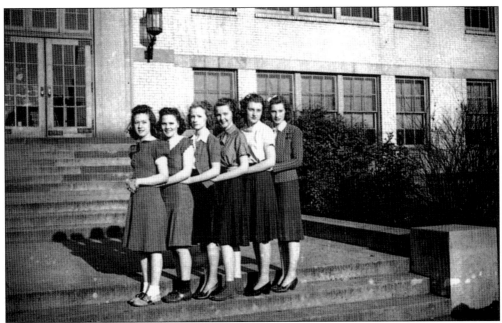

BASKETBALL QUEEN CANDIDATES. The six candidates for basketball queen, two from each class, pose in front of the high school on Vincennes Street in February 1940. On Friday, February 23, 1940, during half time of the New Albany versus Fort Wayne game, New Albany team captain "Boner" McAfee presented Jacqueline (Jackie) Bir with a gold necklace and the title of basketball queen. Pictured from left to right are Maxine McGovern, Jane Borkenheim, Jean Bir, Margaret Mary Zweigard, Bonnie Ratliff, and Jackie Bir.

RELAXING IN THE RIVER. Before the Corps of Engineers began taming them, the waters of the Ohio River sometimes fell so low that bathers could relax in the slow moving currents. From left to right in this photograph taken on June 23, 1930, are (first row) Edward and Alice Gullett; (second row) Morris and Martha Gullett, and Richard Prince. (Courtesy Sharon Gullett.)

FREIBERGER BROTHERS AND SISTER. Brothers Glen, Charles, Mark, and Duane relax in a swimming pool in the backyard of the Gullett home on Grantline Road with their sister, Janice, in 1962. Janice, second from the left, is identified only because her hair is longer than that of her brothers. (Courtesy Sharon Gullett.)

BERT AND NEOLA COLLINS. The couple share a lighthearted moment in 1940 at one of the city's numerous parks. From Jaycee Park along the river to Community Park in the north, New Albany has always set aside land for those seeking recreation in a natural setting. Athletes can play tennis, basketball, baseball, and softball on any of the numerous courts and fields located throughout the city.

DOROTHA LILLY AND TATER. Dorotha Lilly (left) and her friend, identified only as Tater, relax at an unidentified park in New Albany sometime in the 1940s. Swimming, in the Ohio River or Silver Creek, was always popular among New Albanians; they could also enjoy one of the many public pools that have been located throughout the city. (Courtesy Janice Bilbro.)

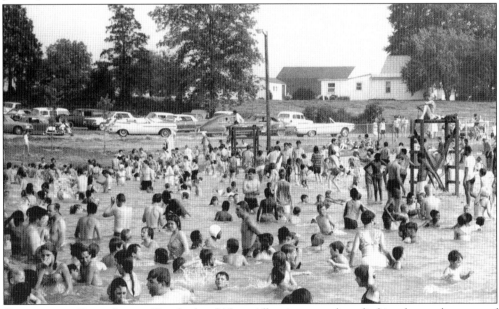

COMMUNITY PARK LAKE. Hundreds of New Albanians sought relief in the cool waters of the lake from the heat and humidity typical of Ohio Valley summers. Photographer Ed Moss captured these bathers on June 9, 1968. Health concerns, low attendance, and rising insurance costs forced the parks department to end swimming in the lake in the early 1970s, but bathers simply used one of the three public pools in the city for relief. (Courtesy Indiana Room.)

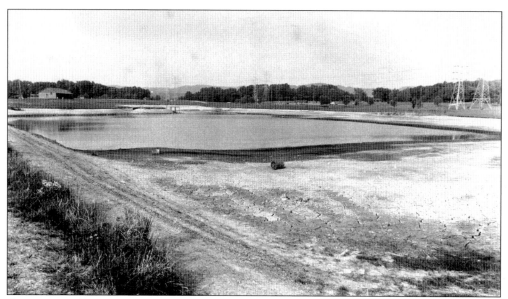

COMMUNITY PARK LAKE, 1983. Neglect and mismanagement caused an overabundance of trash fish, and on Wednesday, July 20, 1983, parks department employee Brad Bower began draining the lake. By September, the water was low enough to allow three days of dip net fishing. Today after years of proper care and management, the lake waters are clean and the fishing is great. (Courtesy Indiana Room.)

MAKING APPLE BUTTER. Judging from the smile on the faces of those involved, the chore of making apple butter was a pleasant pastime when this photograph was made in the backyard of Charles and Geneva Gullett's home on Grantline Road in 1970. James Freiberger adds another log under the watchful eye of his brother Melvin, while Geneva waits to stir the boiling mixture. (Courtesy Sharon Gullett.)

Eight

DISASTERS

Earth, wind, fire, and water have all sculpted New Albany's landscape and affected the town's residents throughout the city's history. When the New Madrid fault shifted in 1813, the quaking earth shook church bells, cracked foundations, and broke several windows in nearby Louisville, but there is no record of the tremor's effects on New Albany, although it is unlikely the sparsely populated area suffered much damage. A massive fire destroyed much of the west end of the city in 1890. The area never completely recovered from the inferno and remains the most economically depressed section of town. There are, obviously, no pictures of the damage done by the earthquake, and because photography was still in its early stages, images of the fire are scarce. However, hundreds, if not thousands, of pictures were taken of the damage wrought by the two remaining elements: wind and water.

Amateur and professional photographers recorded the carnage when a tornado the *New Albany Daily Ledger* described as a "supernatural something" scoured a path from State Street to Charlestown Road. The "greenish-black cloud of hellish proportions" descended on the unsuspecting city from the Silver Hills at 3:00 p.m. on a warm Friday afternoon in March 1917, and whole blocks were wiped so clean that it was impossible to tell where the houses once stood. More than 300 homes were completely destroyed, scores more damaged, and five factories employing 300 people were demolished. Damages were estimated at over $2 million. When the Ohio River inundated the city in January 1937, official government photographers, insurance agents, and private citizens recording what was probably the most momentous natural disaster they would ever experience, took thousands of photographs of the devastation.

Some of the photographs of these two disasters and other calamities that befell the city are included in this chapter.

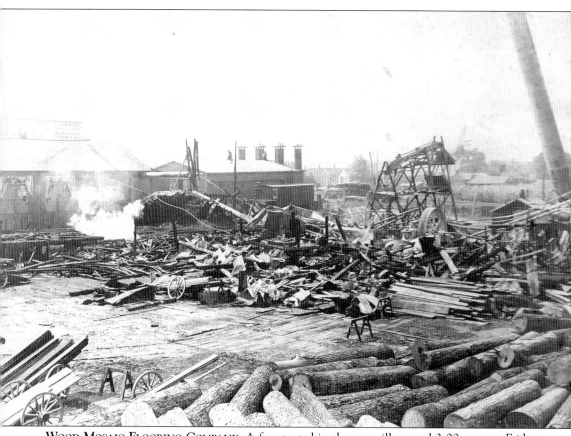

WOOD MOSAIC FLOORING COMPANY. A fire started in the sawmill around 3:00 p.m. on Friday, August 1, 1913, and spread through the Wood Mosaic Flooring Company complex by a system of fans and ductwork designed to carry away sawdust. The factory, opened in 1898 on 10 acres along Troy and Main Streets just east of Eighteenth Street, was destroyed. No one was aware of the blaze until flames, at times rising more than 100 feet into the air, began erupting all over the complex. The conflagration spread rapidly, and firemen battling the blaze had to abandon over 700 feet of hose and flee for their lives. A total of 17 homes were consumed when strong winds carried the flames south and west of the factory. Most of the occupants were renters and none had insurance. Total damages for the factory and the homes were estimated at $300,000, and though several people were injured, some seriously, no one died in the disaster. The plant, the city's second largest employer at the time of the disaster, later reopened. (Courtesy Helen L. Baker.)

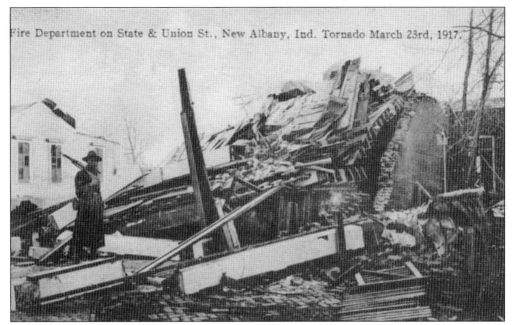

Fire Department on State & Union St., New Albany, Ind. Tornado March 23rd, 1917.

REEL HOUSE NO. 4. Shortly after 3:00 in the afternoon of March 23, 1917, a tornado swept down out of a ravine in the Silver Hills in the northeast section of New Albany. The cyclone, described by the *New Albany Daily Ledger* as having "supernatural power," devastated Reel House No. 4 on State Street, and although no firemen were killed in the destruction of their firehouse, 37 New Albanians were killed by the cyclone.

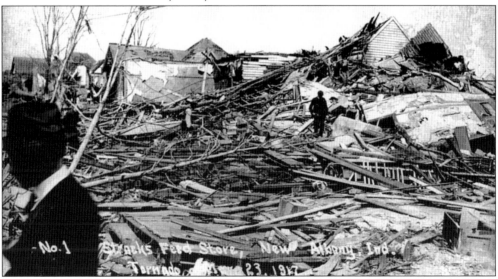

STRACK'S FEED STORE. "One of the many extraordinary things that occurred in yesterday's death dealing cyclone was the one that happened when Henry Strack, who on hearing the roar of the coming storm, stepped to the door of his place of business, and as he did so, the wind picked him up and carried him at least three squares. In the terrible experience, Mr. Strack was severely injured. At the same time this occurred, Clarence Moss, who was inside of the store, was thrown violently, his head being severed and his body badly mangled," wrote the *New Albany Daily Ledger.*

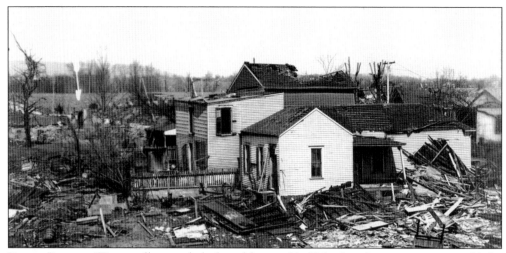

PEARL STREET. "Two small negro lads, breathless and half dead with excitement . . . told the story of the carnage at the negro school on Pearl Street. . . . The Oldham school for colored children, Pearl and Union streets, was completely destroyed. It is reported that there were about thirty-five children in the school when the tornado came up, and the latest report is that four children have thus far been taken dead from the ruins. How many more may be found is uncertain," wrote the *New Albany Daily Ledger* on March 27, 1917. The arrow points to the remains of the school. (Courtesy Indiana Room.)

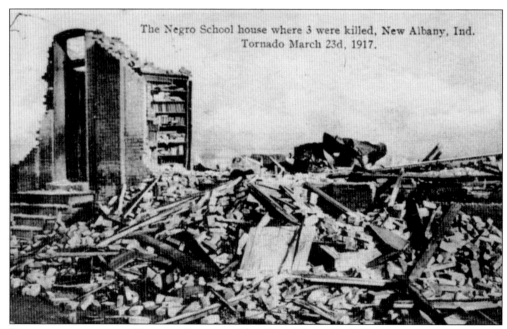

DEVASTATION AT THE OLDHAM SCHOOL. The *New Albany Daily Ledger* account continued: "The school was a brick structure, but in the sweep of the gale, it crumbled like a house of blocks. Several children are injured, some seriously. It was indeed a pitiful sight to see the little bodies being carried away from the ruins. Though covered up, occasionally a chubby little hand could be seen dangling from beneath the covers. Such sights touched the strongest hearts." The tornado destroyed the brick building, but left books sitting on shelves.

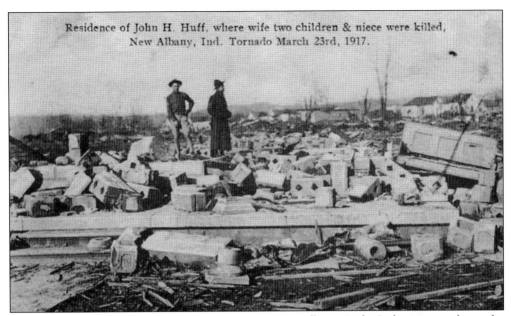

Residence of John H. Huff, where wife two children & niece were killed, New Albany, Ind. Tornado March 23rd, 1917.

HUFF FAMILY HOME ON EALY STREET. The *New Albany Daily Ledger* reported on the destruction on Ealy Street: "Eleven dead in four adjoining houses in one block on Ealy Street between West Street and Crystal Avenue was the tornado's most merciless toll in the whole city. Eight of these were hurled many blocks and hurled at the caprices of the wind wherever the wind chose."

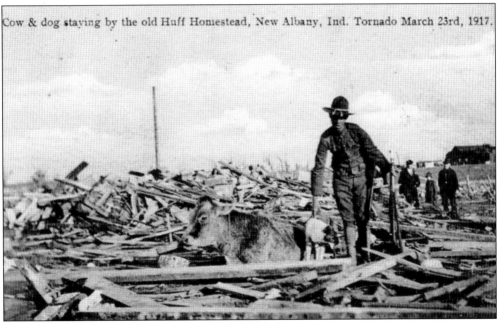

Cow & dog staying by the old Huff Homestead, New Albany, Ind. Tornado March 23rd, 1917.

THE ONLY SURVIVORS. A National Guardsman watches over a cow and a dog, the only survivors at the Huff homestead. Mrs. Huff, two of her children, and her young niece Rose were killed when the house was destroyed. A total of 15 other houses in the area were also demolished, and the complete destruction of the concrete and block homes provides strong evidence that the tornado was an F-5 on the Fujita scale

King Residence on Olden St., New Albany, Ind. Tornado March 23rd, 1917.

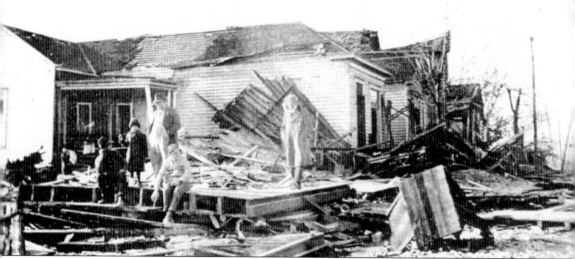

THE KING FAMILY RESIDENCE ON PEARL STREET. The families of brothers George and Charles King lived next door to each other on Pearl Street; one at 1116, and the other at 1118. Which home is pictured in this photograph is unknown. Neither brother was hurt, but George's wife had both legs broken, and Charles's spouse suffered severe internal injuries. As rescuers combed through the wreckage searching for survivors trapped beneath the debris, they heard a voice faintly call, "Mother." When they frantically began clearing away the debris, the cry stopped. The rescuers halted their digging, and the voice resumed its pitiful plea. The diggers reached the stove, which had fallen through the kitchen floor, and the pitiful call seemed to come from the appliance. One can only imagine their surprise when they opened the oven door, and a huge parrot belonging to Grace King flew out. The bird, which called Grace's mother Barbara "mother," had somehow ended up in the oven, uttering his sorrowful plea when he thought no one was close by.

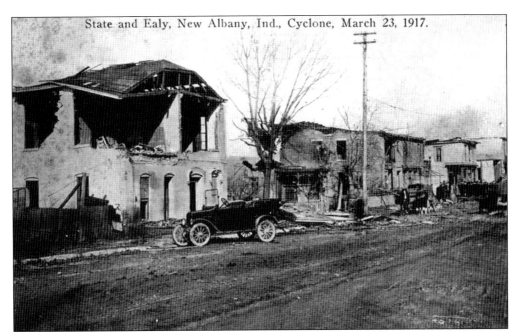

OLD PIKE INN ON STATE STREET. The tornado gained size and strength as it tore through the homes on Ealy Street. Louis Denison grabbed a telephone pole in front of a grocery store to keep from being blown away, and witnesses watched in amazement as the wind whirled the 15 year old around the pole. The storm was almost a mile wide by the time it reached this area of State Street.

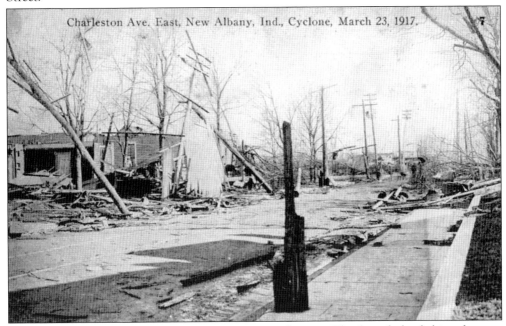

EAST ON CHARLESTOWN ROAD FROM VINCENNES STREET. The funnel cloud skipped over a depression in the terrain and resumed its destructive path down Charlestown Road. One family gathered together outside the ruins of their home; all were injured except for the youngest member of the family. The baby, blown out of the side of the home, lay uninjured a short distance away.

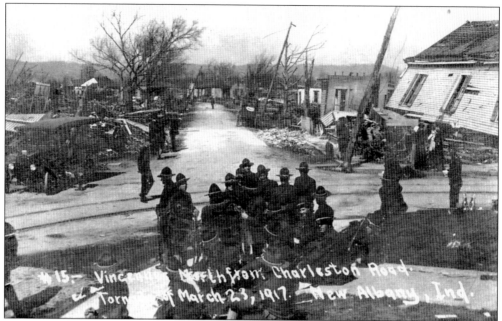

THE INTERSECTION OF CHARLESTOWN ROAD AND VINCENNES STREET. Troop D of the Indiana National Guard posed in the intersection of Charlestown Road and Vincennes Street on March 27, 1917. The tornado destroyed several homes as it continued west along Charlestown Road. Lopp's Grocery, the lopsided structure on the right, was returned to its foundation, and residents today will recognize the building as the Little Tiger Food Mart.

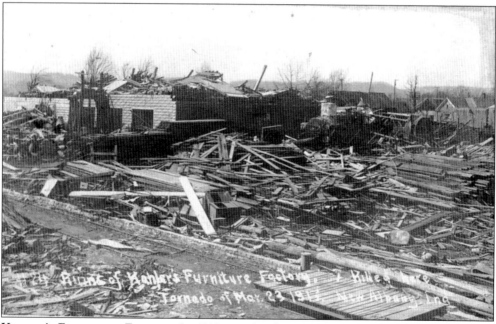

KAHLER'S FURNITURE FACTORY. In 1912, woodworker Ferd Kahler built the first automobile in New Albany at his woodworking factory on the northwest corner of Vincennes Street and Charlestown Road. The car was not a success, and only 12 were built. Five years later, seven of his employees lay dead in the ruins of his factory.

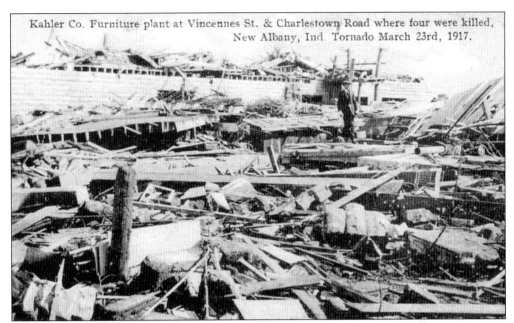

Kahler Co. Furniture plant at Vincennes St. & Charlestown Road where four were killed, New Albany, Ind. Tornado March 23rd, 1917.

KAHLER'S. An unidentified man walks through the ruins of Kahler's factory. Kahler decided not to rebuild on the location, and two rows of blocks from the wall in the background are all that remain of the former factory. Mathes Drug Store currently occupies the site where this photograph was taken.

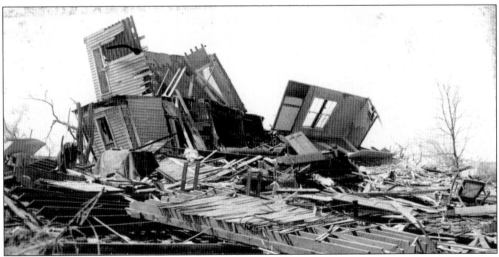

MARZIAN RESIDENCE, CHARLESTOWN ROAD. Albert F. Marzian was a composer and publisher of such ragtime hits as "Aviation Rag," "Food Rag," and "Angel Food Rag." He often published his music under the nom de plume Mark Janza, a play on his Russian father's name of Marjanza. Marzian was not injured, but his wife suffered a broken leg, hip, and shoulder. The couple moved to Louisville after her recovery. (Courtesy Indiana Room.)

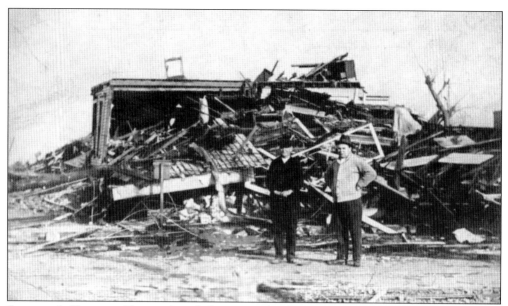

STEINERT'S GROCERY. Two unidentified men stand in front of the ruins of Steinert's Grocery on Charlestown Road. Steinert rebuilt his store, and in 1961, his grandson Jim Steinert remodeled the building and opened Steinert's Café, a popular local restaurant and nightspot where patrons can listen to live music or watch their favorite sports on one of the large screen televisions strategically placed around the bar. (Courtesy Indiana Room.)

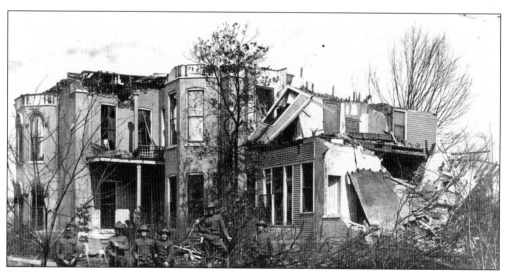

DePAUW APARTMENTS. Summer homes were fashionable for New Albany's Gilded Age tycoons. This is what remained of C. W. DePauw's summer retreat on Charlestown Road on March 23, 1917. DePauw's widow, who lived in a small apartment behind her former home, was badly injured. None of her boarders were seriously hurt, and no one died. (Courtesy Indiana Room.)

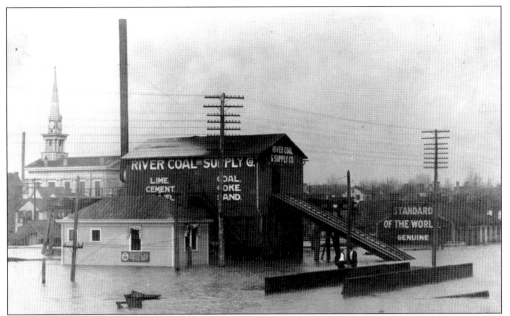

MARCH 1913. River Coal and Supply Company, located at the foot of Pearl Street, was flooded when the Ohio River rose 56 inches on the night of March 26, 1913, in what the *New Albany Daily Ledger* claimed was the "most phenomenal rise ever recorded." The water continued to rise at a rate of eight inches an hour on March 27, and when the river finally crested at 45 feet on April 1, some 60 blocks in the city were submerged.

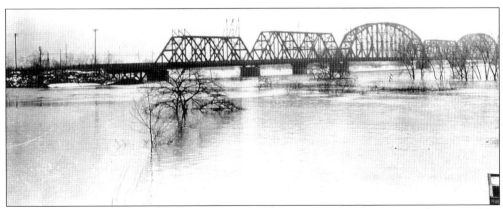

KENTUCKY AND INDIANA RAILROAD BRIDGE. This photograph gives some indication of the depth of the floodwaters in 1937. Built in 1912, the sturdy iron bridge remained open during the flood. Although closed to vehicle traffic after an accident in 1974, trains still regularly cross the almost century-old structure, and current plans are to reopen the Kentucky and Indiana Bridge to bicyclists and pedestrians. (Courtesy David Barksdale.)

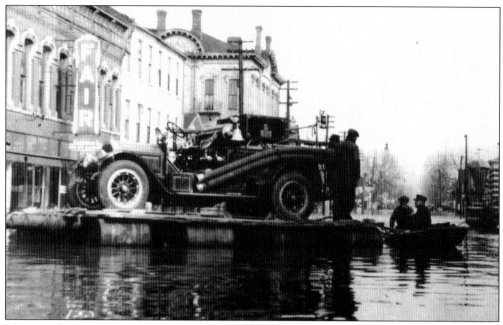

MARKET STREET. Several residents owed their lives to this crude pontoon boat, built by the city's firemen during the 1937 flood. New Albany fire chief John Feiock Jr. and Harry Howard row up to the Rube Goldberg contraption between Pearl and Bank Streets. Howard worked for Warner Brother's studios in Hollywood, and was visiting his hometown when the floodwaters struck. The two men on the pontoon are unidentified. (Courtesy Indiana Room.)

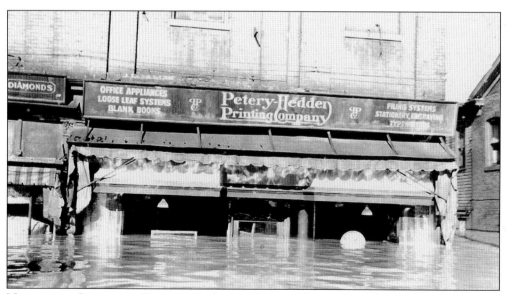

NORTHEAST CORNER OF PEARL AND SPRING STREETS. Located on the Spring Street side of the Opera House, the Petery Hedden Printing and Supplies Company was inundated by the floodwaters in 1937. The company survived the flood and later moved to their current location at 216 Pearl Street. (Courtesy David Barksdale.)

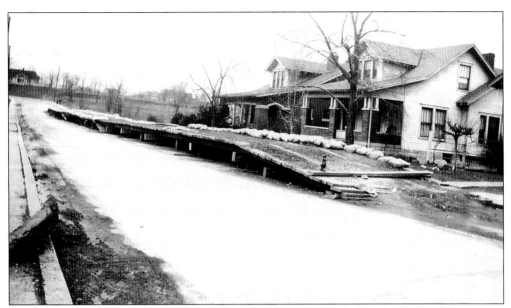

SILVER STREET. The deepest water covering the city was recorded at the corner of Silver and Spring Streets. On the other end of Silver Street, this temporary bridge allowed residents stranded on a small island surrounded by the floodwaters access to and from their homes. The view in this photograph is looking north on Silver Street toward Charlestown Road. (Courtesy David Barksdale.)

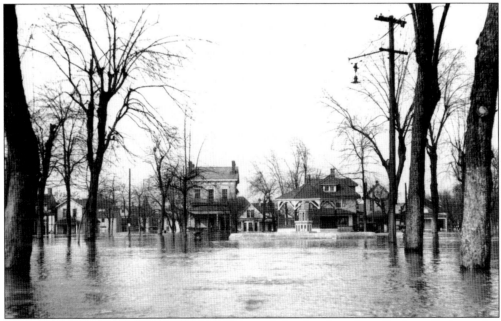

SCRIBNER PARK. The 1937 floodwaters surround the bandstand in Scribner Park in this photograph looking down LaFayette Avenue. The park and LaFayette Avenue survived the flood, but were removed when the Sherman Minton Bridge and Interstate 64 were built in the late 1950s and early 1960s. (Courtesy Indiana Room.)

VINCENNES STREET. The rising floodwaters surrounded New Albany High School, and classes were cancelled. A state of emergency existed from January 20 until February 11, 1937. Hundreds of New Albany's families lost their possessions and homes, and over $8 million worth of damage were claimed when the waters receded. (Courtesy David Barksdale.)

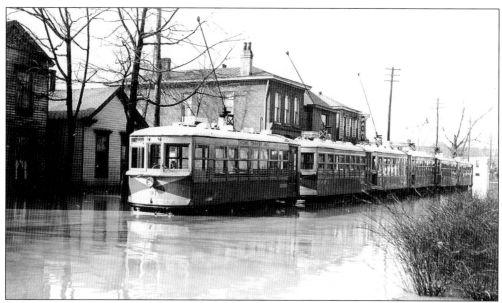

VINCENNES STREET TROLLEY. Evidence of the swiftness with which the waters rose is provided in this photograph of the Vincennes Street trolley stranded in front of New Albany High School. More than 5,000 people who lost everything in the swiftly rising waters applied for aid. (Courtesy David Barksdale.)

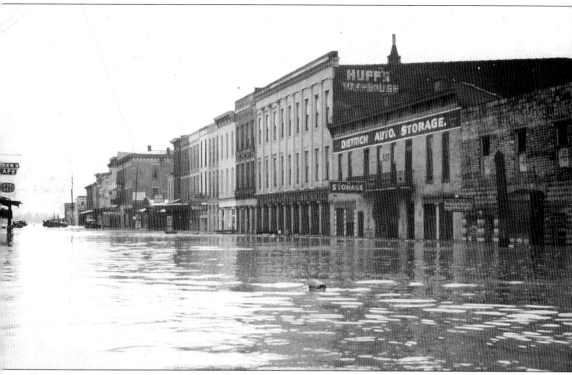

EAST FOURTH STREET. In 1888, tailor Frank Morgan opened the city's largest store on the corner of Pearl and Main Streets. He later moved his business to East Fourth and Spring Streets, and in 1937, the floodwaters inundated the business. The view is looking north up East Fourth Street from Spring Street. (Courtesy Indiana Room.)

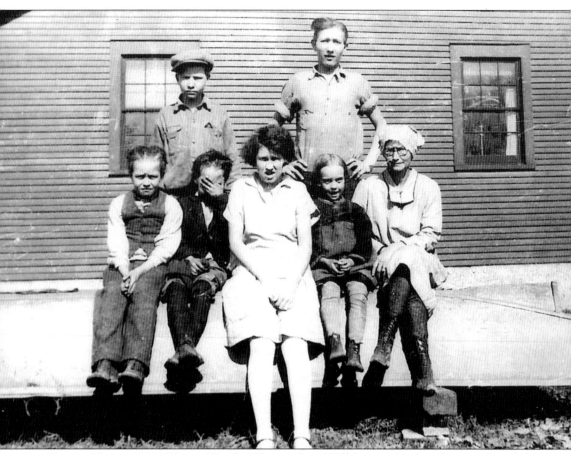

FAMILY HOME, 1927. Winnie Wyrtle Whitten (née Walls) poses for this photograph with her children and two of her nephews in the side yard of her home on River Road. Seated on the overturned skiff are, from left to right, Kepley and Sherman Whitten, Bertha McCoy, Evelyn Whitten, and their mother, Winnie. Charles Gullett, right, stands behind his aunt and cousins with his brother Morris. (Courtesy Sharon Gullett.)

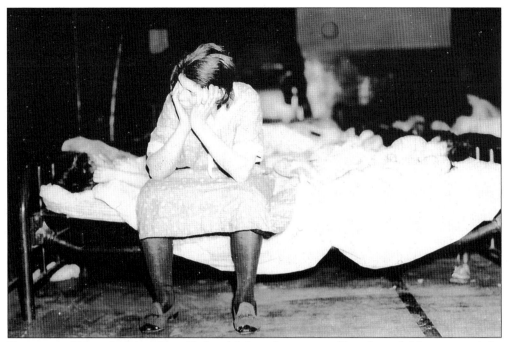

REFUGEES. Although this unidentified and dejected woman and her three children escaped the rapidly rising waters, they lost all of their possessions. Any family that had lost a home valued between $900 and $1,300 was given their choice of one of 20 pre-fabricated houses, the first in the nation, built by the Gunnison Corporation on Charlestown Road, or one of 20 conventional homes built by contractor Calvin Brewer. Only 16 families applied for the housing, and the New Albany Housing Authority was established to administer the low-income housing in the Valley View Housing Project. (Courtesy David Barksdale.)

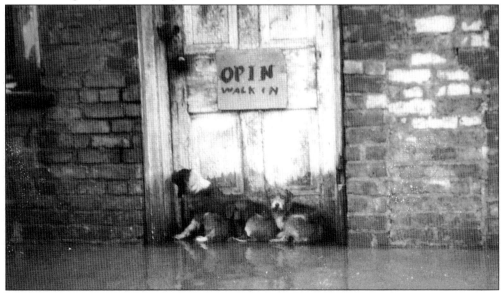

MORE REFUGEES. People were not the only refugees seeking shelter from the rising floodwaters. This mother and her puppies were rescued after the owners of the building where the animals sought shelter refused to "opin" the door to them. (Courtesy David Barksdale.)

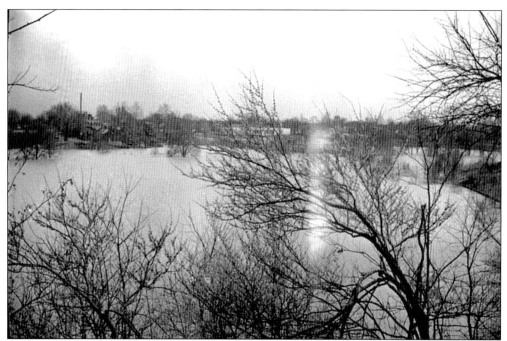

VALLEY VIEW PARK. New Albanians watched apprehensively as the rising waters of the Ohio River backed up into the many creeks and tributaries that flowed into it. On April 25, 1940, the river crested at 62 feet, and the rising backwaters flooded Valley View Park. The editor of the *New Albany Daily Tribune* remarked: "This year's flood was similar to the one in 1939 in point of crest and amount of inconvenience."

A UFO? Charlie Gullett posed beneath this donut shaped cloud in the backyard of his home on Grantline Road. The strange looking cloud, which usually precedes dangerous weather, passed over the area on Easter Sunday, April 17, 1938. Gullett said the weather was calm and beautiful and remained that way for the rest of the day. (Courtesy Sharon Gullett.)

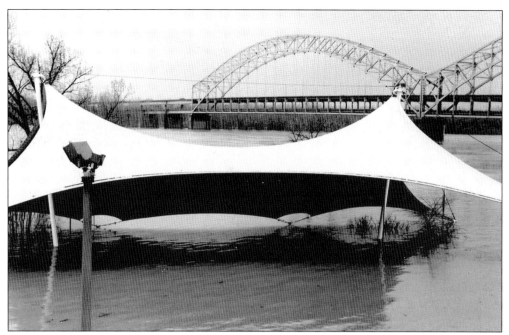

NEW ALBANY AMPHITHEATER. More than a foot of rain fell during the night of February 28, 1997, on ground saturated earlier that winter by heavy snows and rain. Despite the decades of valiant efforts by the Army Corps of Engineers to tame the mighty river, New Albanians rose on Saturday morning, March 1, 1997 to find parts of their city covered by the deepest floodwaters in 60 years. (Courtesy Chris Nance.)

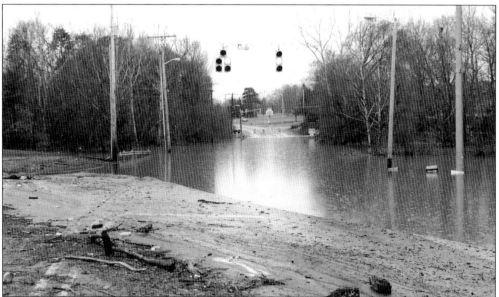

CHARLESTOWN AND MOUNT TABOR ROADS. When the corps installed a flood wall during a federal flood control project begun in response to the 1937 disaster, some residents complained that the city was being cut off from its river heritage. Some 60 years later, New Albanians expressed gratitude for the wall, but even that great buttress offered little protection against the rising waters of the numerous creeks in the city. (Courtesy Chris Nance.)

ACROSS AMERICA, PEOPLE ARE DISCOVERING SOMETHING WONDERFUL. *THEIR HERITAGE.*

Arcadia Publishing is the leading local history publisher in the United States. With more than 3,000 titles in print and hundreds of new titles released every year, Arcadia has extensive specialized experience chronicling the history of communities and celebrating America's hidden stories, bringing to life the people, places, and events from the past. To discover the history of other communities across the nation, please visit:

www.arcadiapublishing.com

Customized search tools allow you to find regional history books about the town where you grew up, the cities where your friends and family live, the town where your parents met, or even that retirement spot you've been dreaming about.